HIGH ROCKS
AND ICE

Serac near Steamboat
Prow on the division of
the Emmons and Winthrop
Glaciers, Mount Rainier

HIGH ROCKS
AND ICE

*The Classic Mountain
Photographs of Bob and Ira Spring*

IRA SPRING

WITH A FOREWORD BY JOHN HARLIN III

FALCON®

GUILFORD, CONNECTICUT
HELENA, MONTANA
AN IMPRINT OF THE GLOBE PEQUOT PRESS

Falcon is a registered trademark of The Globe Pequot Press.

Phyllis Munday stamp page 71 © Canada Post Corporation, 1998. Repro-
duced with permission.

All photographs by Bob and Ira Spring unless otherwise noted.
Text design: Casey Shain

Page i: the Cascade Mountains; pages vi and vii: a tributary of the Hoh
River, Mount Olympus.

Library of Congress Cataloging-in-Publication Data
Spring, Ira.
 High rocks and ice: the classic mountain photographs of Bob and Ira
Spring/text by Ira Spring; photographs by Bob and Ira Spring —1st ed.
 p.cm.—(A Falcon Guide)
 ISBN 0-7627-3057-9
 1. Mountaineering. 2. Photography of mountains. 3. Mountains—
Pictorial works. I. Spring, Bob, 1918– II. Title. III. Series.

 GV200.S67 2003
 796.52'2—DC22 2003060673

Printed in China
First Edition/First Printing

Gnome Tarn and Prusik Peak have
only recently emerged from glaciers.

CONTENTS

A crevasse in the Ingraham Glacier, Mount Rainer

Foreword

If you've come of outdoor-age in the Pacific
Northwest, chances are you remember landscapes
and adventures you've never experienced. So
ubiquitous were the camera lenses of Bob and Ira
Spring, and so (deservedly) published their
images, that most of us who loved the
Northwest's mountains in the second half of the
twentieth century have trouble separating some
of our personal memories from the images we've
savored on the printed page.

As a Cascades-crazed teenager of the
1960s, I remember marveling at how that "first
couple" of mountain photography (Bob and Ira)
had seemingly been everywhere and inspired
everyone. Not until I was grown and returned to
the Northwest after a twenty-year absence did I
finally get to meet Ira. Fortunately, by then I'd
already learned that he was not Bob's wife, but
his adventurous twin brother. I'd also learned that
Ira's ability to inspire had moved well beyond the
lens alone.

When we met in the late 1990s, he was
using his personal powers of persuasion, com-
bined with his vast experience in the Northwest
hinterlands, to lobby for trails and wildland
protection. He'd coined a term and an eloquent
philosophy for what many of us floundered to
define: *green-bonding*. In other words, contact
with nature engenders appreciation for nature, a
mutually reenforcing cycle that's equally good for
wild places and for the people who love them. To
further propel the message, Ira founded his Spring
Family Trust, through which the considerable pro-
ceeds from the sale of his guidebooks were plowed
back into trail maintenance and protection of land.

Most professionals in the world of out-
door publishing have struggled with the conun-
drum of whether we are doing more harm than
good by encouraging people to explore wild
places. Ira resolved this issue, for me at least, and
for that I'm almost as grateful as for those early
images of hikers reflected in mirror-still alpine
lakes that helped so much to build my own pas-
sion for Washington's mountains.

Thank you, Ira, for bringing us into your
world—and for showing us how to care for it so
that our grandchildren's grandchildren can love it
as we have.

John Harlin III
EDITOR, *American Alpine Journal*,
CONTRIBUTING EDITOR, *Backpacker* magazine

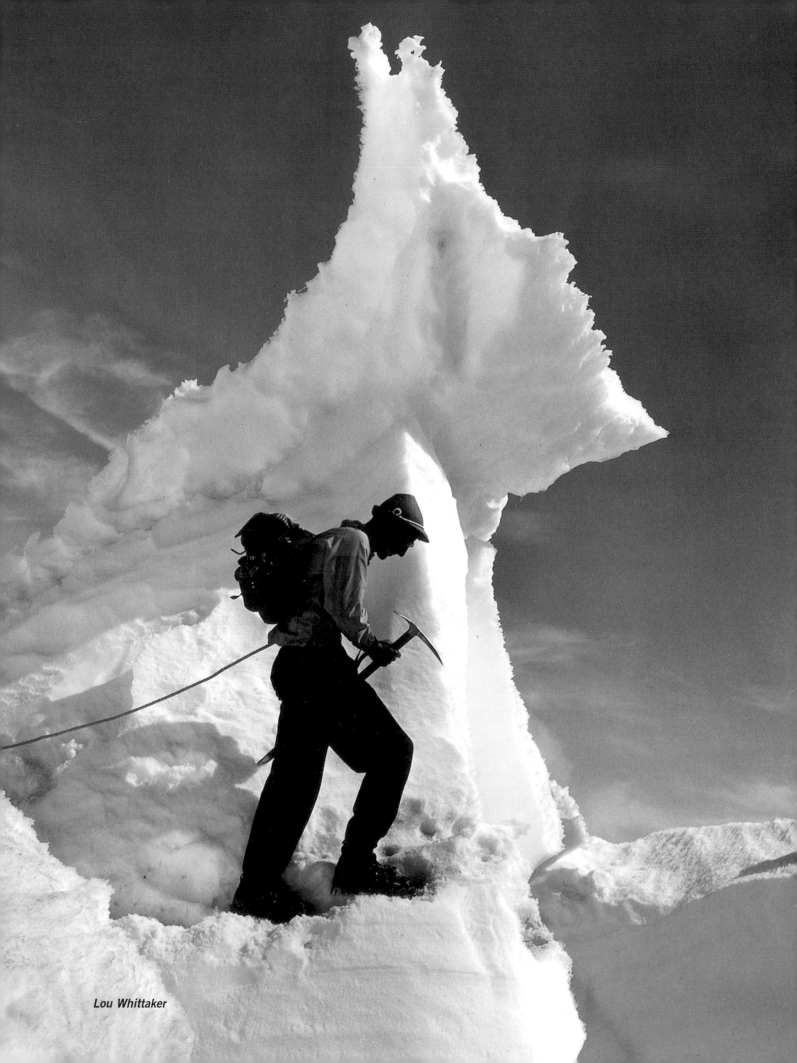

Lou Whittaker

Introduction

My twin brother, Bob, and I did not deliberately set out to chronicle the "Classic Age" of Mountaineering. It just turned out that way. And in doing so, our photographs have become classics themselves. At a time when other photographers were recording expeditions to such distant places as Alaska, the Himalayas, and South America, we were photographing the remarkable climbers and stunning peaks of the Pacific Northwest. We were among the first to make a career of hauling heavy, professional camera gear up the Cascade and Olympic Mountains to capture their beauty. The photos in this book are from climbing stories that were published in all the major magazines of that era: the *Saturday Evening Post, Esquire, Colliers, Time, Life, National Geographic*, and more. Between 1946 and 1970 the *Seattle Times* featured 250 of our stories on hiking, climbing, water sports, and logging. We sold hundreds of photos for calendars, book illustrations, and advertising. Our first book, *High Adventure*, was published in 1951; it was followed over the years by fifty-five others that we have either authored or coauthored. We feel privileged to have been able to photograph so much of the area's climbing.

But when did Northwest climbing begin?

Native Americans, trappers, and prospectors were the first to tread on Pacific Northwest mountains, even though they left no record. The first description of local mountain exploration came in 1833, when Dr. William Fraser Tolmie, a Hudson's Bay Company employee from Fort Nisqually, became the first white man to visit the slopes of Mount Rainier and wrote of his exploits. Although Tolmie's summit attempt failed, it ushered in what I call our "Golden Age" of mountaineering, when all the major Northwest peaks were scaled.

My first ascent of a mountain came in 1929, at the beginning of what I think of as the "Classic Age." During this time pioneering climbers put up difficult routes on all the major peaks. Wolf Bauer led the first ascent of Mount Rainier's Ptarmigan Ridge on September 7, 1935; Ome Daiber did a first on Liberty Ridge twenty-two days later.

During the 1950s and 1960s, climbers such as Dee Molenaar, Jim and Lou Whittaker, Fred Beckey, and Pete Schoening were on the leading edge of the sport, employing the best equipment available at the time. Rubber-lug boot soles were replacing Triconi nails, manila ropes were tossed out in favor of much stronger synthetic goldline, and alpenstocks gave way to ice

axes. Innovative gear—devised in basements, metal shops, and sewing rooms—showed up in climbers' packs and soon became commercially produced.

The 1990s were the "Extreme Sports" age. As the popularity of climbing grew, so did new techniques and gear. More routes were established on challenging peaks, and climbing gear companies offered exotic new equipment to help alpinists reach the top. Today's climbers continue to push the limits: In another twenty years, current hot techniques and high-tech gear will undoubtedly seem as primitive as alpenstocks and Triconi nails do now.

Our only surviving original Box Brownie

I don't remember ever being especially thrilled when I reached a mountain top—it was the adventure of getting there that I loved. To me the attraction was the beauty that surrounded me as I hiked a wilderness trail or climbed a peak, as well as the challenge of it. I especially loved the wonderful shapes of crevasses, seracs, and other snow formations that I found on glaciers and the play of sunlight on snow and rock. The physical challenge of a climb can be measured by miles walked and thousands of feet gained. To a photographer however, mountains present the mental challenge of capturing the beauty on film. And

for a professional photographer, the final reward is represented by the editors who like the pictures—and buy them.

I think luck had a lot to do with it. In our search for adventure, Bob and I were lucky to grow up in a family that loved wilderness camping. In 1929, when we were eleven, Dad got us started hiking and climbing on our first overnight backpack in the Olympic Mountains. Our next piece of great luck came in 1930, when Eastman Kodak celebrated its fiftieth anniversary by offering every twelve-year-old in the United States a Box Brownie camera. Among these fortunate youths were Bob and I, and we quickly found that mountains and cameras go together like peanut butter and jelly.

Only half of all American families (and no kids) owned cameras back then. The anniversary camera was ideal for us beginners because the Box Brownie had no adjustments for twelve-year-olds to struggle with. The focus was fixed at 10 feet or so, the one lens opening was about f8, and the shutter speed averaged 1/25 of a second. Point-and-shoot at its best, that was all there was to it. Those cameras inspired both Bob and me to choose photographic careers. My luck continued

when a 1937 summer job at Mount Rainier allowed me to spend my free time exploring the slopes and learning, by trial and error, how to take mountain pictures.

After a World War II stint in the Army, Bob and I became business partners, specializing in mountain photography. In 1970 Bob was attracted by a different branch of our career, tourism, and became a contract photographer for airlines, hotel chains, and tour boats. I stayed with the outdoors, and since the 1960s have been the photographer and coauthor of the *100 Hikes* series of guidebooks, each of which I revise every five to six years. Not content to rest on old achievements, I continue to look for new places to hike, new scenes to photograph, and new books to write.

Ira Spring, 2003

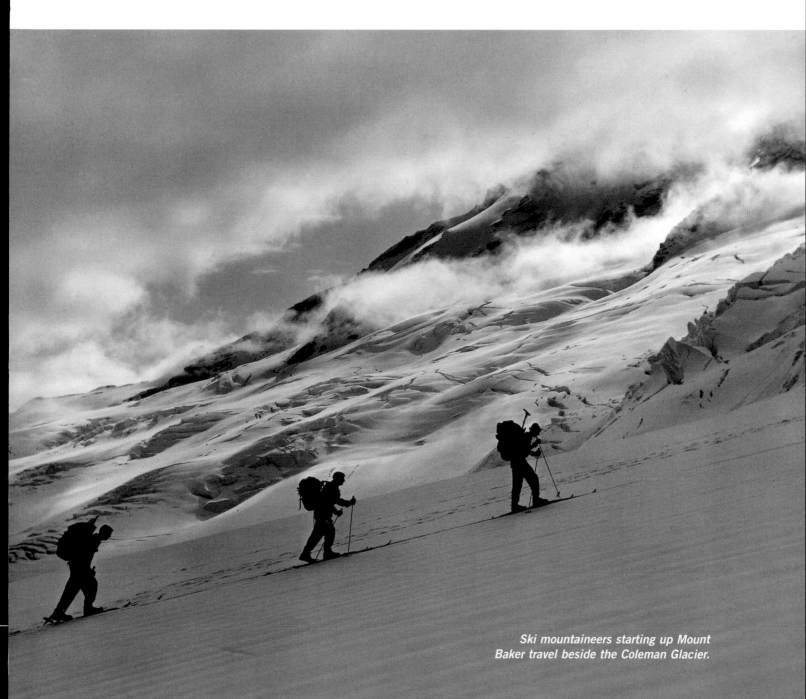

Ski mountaineers starting up Mount Baker travel beside the Coleman Glacier.

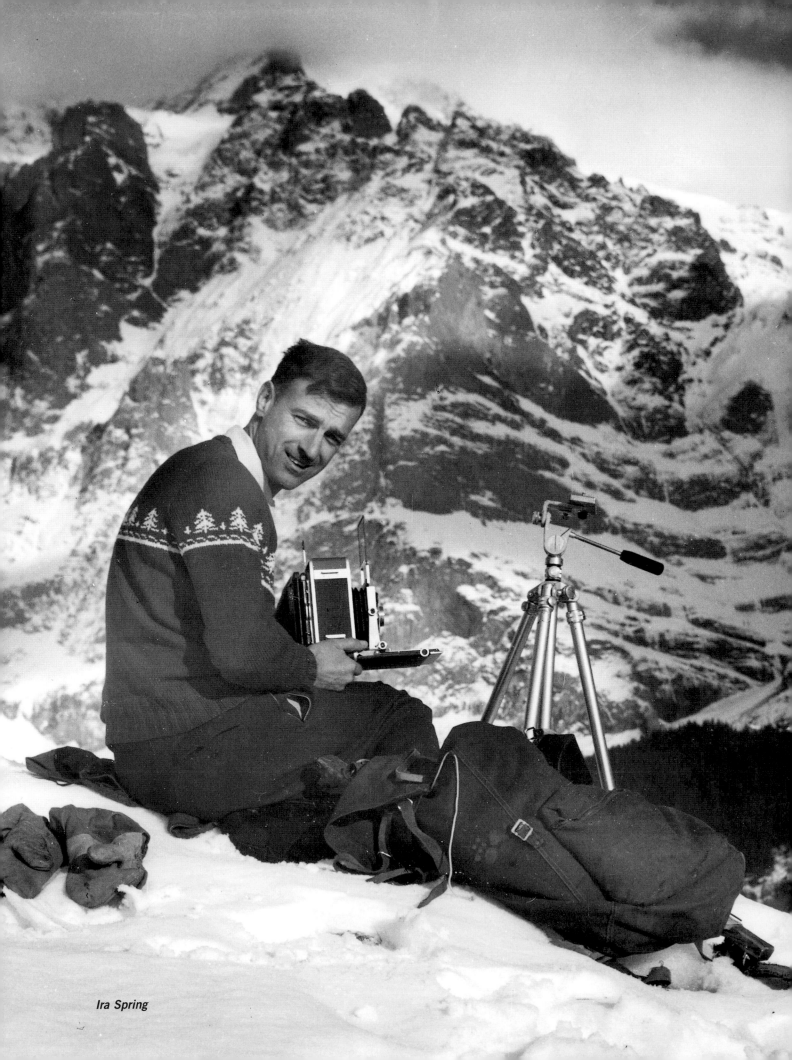

Ira Spring

Of Cameras and Film

Back Where We Started from, Some Seventy Years Ago

It has been more than seventy years since Eastman Kodak gave me my first camera, the Box Brownie. I have a lot more pictures I plan to take, and I expect to be able to do so because modern cameras are much lighter than the 4x5 view camera I started hauling around in 1946. Not only are these new cameras easier on tired old shoulders, but they also include so much electronic gadgetry that they are easy on tired old heads. Film, too, has changed. Inside the body of our 1930 Box Brownie, there is still an advertisement for NC Kodak film, so no doubt that is what we started with, although I don't remember anything about it. Early films were blind to red and oversensitive to blue. Shortly after NC Kodak film came Verichrome, which was still overly sensitive to blue and hardly recorded red. Not until Bob and I were in college was there a panchromatic film that was sensitive to all colors. One marvels at the beautiful black-and-white photographs achieved by such masters as Stieglitz, Steichen, Weston, and Ansel Adams with such slow, insensitive film.

In 1930 color pictures were taken by a complicated process that used three different filters on three different black-and-white negatives. The results were as beautiful as anything that can be done today, but the process was too tedious to be practical. Color film didn't come into use until the late 1930s. It wasn't until 1940 that I bought a six-sheet package of Kodachrome for a trip in the Olympic Mountains (I still have one of those exposed films). The color was great, but the film had a speed of only ASA 6. After World War II the speed was doubled to ASA 12; that was still slow, and the camera had to be set on a tripod for every picture. In 1950 film speed increased to ASA 64. Although ASA 100 is currently the most popular film for professionals, speeds of over 1000 are now on the market.

When Bob and I became partners in 1947, we each had our own Speed Graphic, but we shared a number of other cameras for special projects. The giant was an 8x20 (that's an 8-by-20-inch negative) view camera loaned us by Eastman Kodak for their 20-by-80-foot backlit transparency displayed in New York City's Grand Central Station. Eastman bought a swimming pool for use in processing and printed the film in 20-inch sections. They eventually accepted smaller films, and in 1987 they even enlarged a 35mm film of Ray Atkeson's for the display. Eastman never asked

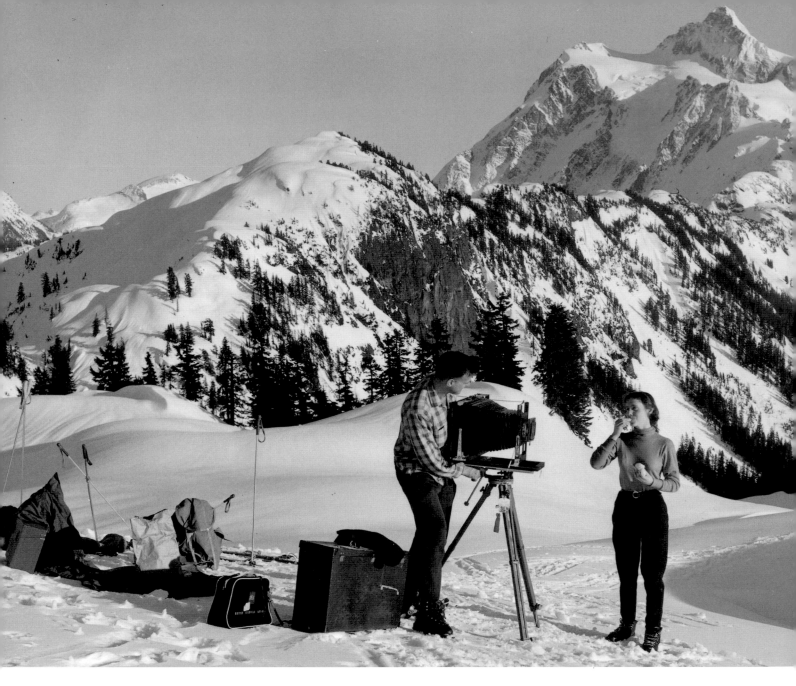

On location with the 8x20 Colorama and Peggy Stark, one of the two models who carried the hundred-pound camera to Artist Point on skis. Mount Shuksan is in the background.

for their big camera back; it is still gathering dust in our basement.

At first, both our black-and-white and our color photographs were made on 4x5 view cameras. At that time art directors wouldn't even look at smaller color transparencies, and today many calendar companies still ask for color films that are 4x5 or larger. *Life* and *National Geographic* pioneered the use of 35mm film; thanks to their high standards, magazine and text-book photographs are now taken mostly with the small camera. A 4x5 is still best for grand scenics that (hopefully) will end up in calendars. However, there is no way to get candid pictures with a large camera—while the camera is being set up, wildlife disappears.

When shooting 4x5 color films, which even in the 1970s cost $1.00 for each film sheet, Bob and I were very careful with our exposures. A reliable meter was standard equipment. For scenic pictures it wasn't necessary to do anything special—we just had to point our lenses at the scene. For snow and glacier pictures however, where proper lighting and exposure are so critical, the light meter had to be treated very differently. Light meters, whether handheld or built into a point-and-shoot camera, will not work on something as brilliant as snow. A meter is not a mind reader; it can only *average* what it sees. Thus in a scene that is largely white, snow becomes gray. Photography books recommend holding a gray card out in front of the meter. I used to carry one in my pack, and it worked fine. When I set the card down, I sometimes kicked snow on it, which melted and ruined the card. One time, in desperation, I pointed the meter at my dirty hand—and found that it worked just as well.

I've taken thousands of pictures in the past seventy years, and I've made almost as many mistakes. I suspect I have some kind of record for boo-boos. I have loaded cameras wrong. I have had them jam. I've gone on long trips and forgotten the film. I once dropped my black-and-white film holder off a cliff and had to finish an assignment using color film and then convert it to black and white. Once I left my camera in a backcoun-try shelter at Flapjack Lakes; because my pack was already so heavy, I never noticed it was missing. My greatest heartbreak was on the Juneau Ice Field. At home in the darkroom, in high excitement I began to develop the spectacular pictures I had taken of Devil's Paw and our lonesome tent on the mile-wide Taku Glacier. I just about committed hara-kiri when I found all my negatives blank. In the cold of 18 degrees below zero, the film had become so brittle that it broke.

We have always developed our own black-and-white films and made our own prints. In the early days we had to get out the scales and mix ten grams of elon, fifteen grams of hydroquinone, and a bit of borax to make our print developer. Now we just open a package of premix. At first we developed our color films, but after a couple of years we gave up. In summer we didn't have time, and in winter we didn't have enough films to warrant mixing the expensive chemicals that would spoil in four days.

Early on, Bob switched to a 35mm camera for his travel work. I belatedly recognized that the 35mm was best for wildlife and flowers and eventually succumbed completely to the lighter camera. Black-and-white sheet film has always been impractical for the 4x5 camera, and the film pack we used isn't manufactured anymore.

From the hundred-pound, 8x20 Colorama camera, we shrank down. When Bob

switched to public relations for tour people and needed pictures of people in action, he switched to a 35mm Nikon. Eventually the weight and loading all the film holders for my 4x5 got to me, so I stepped down to a 2¼ x2¼ Hasselblad. In 1999 I finally caved in and bought a 35mm autofocus Canon camera. I now use it for all my color work. Although my current 35mm camera is a lot more sophisticated than that 1930 free Box Brownie, the principle is the same: Just point and shoot.

What's Next?

Today's automated digital cameras are based on how many millions of pixels there are on a CCD surface. It might be another five or ten years before professional photographers and their customers are ready to give up film for digital, but I believe that day is coming on a fast track. In preparation, I am getting my toes wet with a simple digital camera, akin to the Box Brownie I first started with.

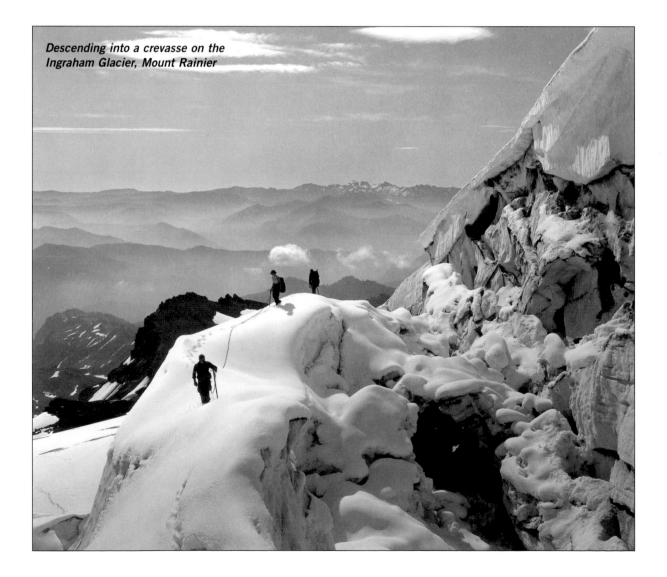

Descending into a crevasse on the Ingraham Glacier, Mount Rainier

Bob Spring

Mount Olympus and a
field of avalanche lilies
from High Divide

High Divide
Olympic Mountains

On a family vacation trip in summer 1929, my mother and my sister Kay stayed at the Soleduck Hot Springs Resort while Dad took Bob and me on our first backpack. We camped 6 miles up the trail, in the three-sided shelter cabin at Deer Lake. Next day, we climbed the crest of the High Divide to the fire lookout atop Bogachiel Peak and dropped down the Hoh Valley slopes far enough for a view of Hoh Lake.

That hike sold me on backpacking. The excitement wasn't from the scenery or the flowers (they must have been there, although I have no recollection of them), but from the morning discovery of ice on our camp water bucket—in high summer! Later, on the High Divide, Dad shoved a big rock off the trail. The rock bounded down the meadows, and a marmot we hadn't seen jumped out of the way just in time. Now *that's* the sort of stuff that gets the attention of an eleven-year-old.

We recalled this hike in 1946 when Bob and I, along with his wife, Norma, used this High Divide approach to climb Mount Olympus. In 1965 I went back to get photos for the first book in our *100 Hikes* series. A couple of other times I went just because it was there.

*Mount Rainier and Puget Sound
Country from Mount Ellinor*

Mount Ellinor

Olympic Mountains

Mount Ellinor was the first real mountain I ever climbed. Back then, before logging roads reached halfway to the summit, the walking started at Lake Cushman, 4,800 feet below the top. That is a whole lot of feet, but Bob and I had teenage energy

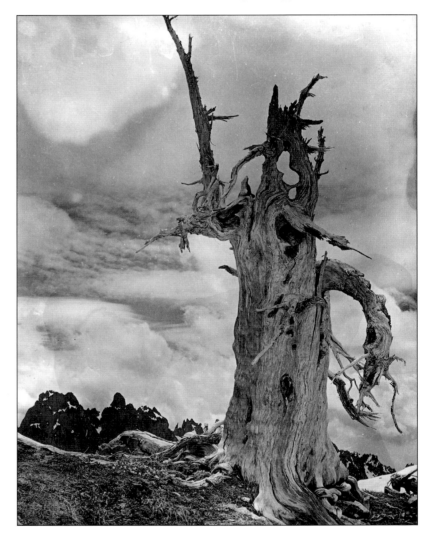

to burn; we made the 4,000-foot ascent at least once a year. The Olympics, after all, were the backyard of our Shelton home. The trail ended 1,000 feet short of the top; the rest of the way was a scramble up a steep gully.

After World War II the scramble up the mountain became very popular when a logging road cut the elevation gain to a mere 2,100 feet. People in street shoes took that in stride and proceeded on up the gully, knocking rocks down on other people in street shoes.

Then seventy-six-year-old Frank Heuston and friends Tom Weilepp (sixty-one) and Frank Maranville (seventy-one) took it upon themselves to build a new section of trail that would bypass the dangerous gully. A decade later, the three were still working Olympic trails once a week, winter and summer.

Mount Rainier from my dormitory window, taken with my Box Brownie

Paradise Inn

Mount Rainier

I was still using my Brownie the summer of 1937 when I landed a job as night janitor at Paradise Inn on Mount Rainier. Most of my daylight hours were spent hiking. In order not to waste time sleeping, I once tried carrying a blanket and lying out on the lateral moraine beside the Nisqually Glacier. Boulders tumbled down cliffs, seracs crashed on the glacier, and every hour or so a monster avalanche swept the Nisqually Icefall—there was just too much going on for me to keep my eyes shut. I had to "waste" some days sleeping in my dormitory. Once, I woke up at dinner time and snapped the picture on the opposite page out the window with my Box Brownie.

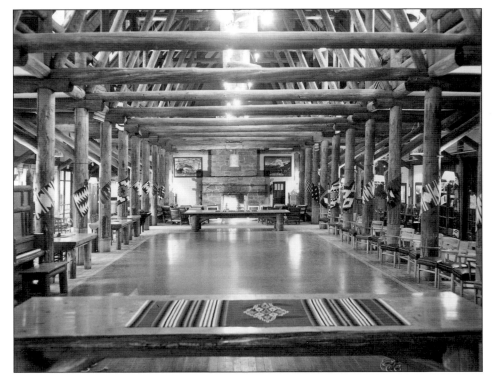

The lobby of Paradise Inn

How many professional photographers got their start with those simple free cameras? A study was done, but I never saw the results; my guess is that it was a lot. I have read that both Ansel Adams and Bradford Washburn began their photographic careers with Box Brownies when teenagers. However, they were the wrong age to receive the free ones of 1930.

Cornice near
Anvil Rock, taken with
my Box Brownie

Anvil Rock

Mount Rainier

On my first night on the janitor's job, I got off work at 6:00 A.M., skipped breakfast, picked up my Box Brownie camera, and headed up the mountain. I wandered around crevasses below Camp Muir and looked over the edge at the Cowlitz Glacier. On the way down I visited Wallace Meade, the firewatcher at Anvil Rock. He scolded me for being unroped and alone on a glacier and pointed out that I had

been standing on a snow bridge when I took my photo. Later, as I learned more about mountains, I realized how lucky I was to have been counseled by people who knew the mountains. Young, eager, and ignorant, I was a prime candidate to be carried home in a basket. Other teachers after Wallace helped keep me lucky.

After talking to the firewatcher, I ran down to the inn in

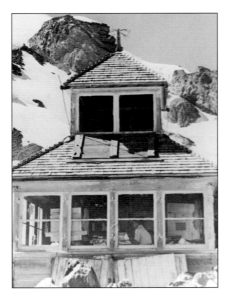
Anvil Rock Lookout

Wallace Meade, the firewatcher

National Park photos

time for lunch, exhilarated by this first day's ramble. I was looking forward to a great summer, starting next day with a climb of Pinnacle Peak. At an employees' meeting after dinner that evening, however, the manager laid down the law. Arrive at mealtime or miss out, dress neatly, and no boys in the girls' dorm (who, me?). Then came the hammer—what I'd heard about limits on hiking wasn't the whole story. Panorama Point was our upward boundary on Rainier, Pinnacle Saddle our boundary in the Tatoosh Range. My planned climb of Pinnacle Peak was not to be—at least not as a park employee.

The Tatoosh Range from Panorama Point. Mount Adams is to the left, and Mount Hood is in the distance to the right.

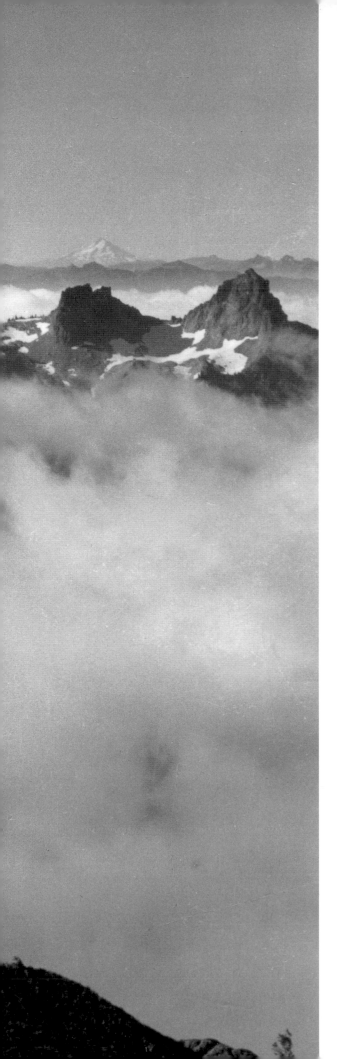

Panorama Point

Mount Rainier

After a night on the job at Mount Rainier, I often went for a hike before eating breakfast and starting my day's sleep. On one such jaunt I took the picture at left of the Tatoosh Range. If the Box Brownie could take pictures like this, who would ever need a better camera? It was at Paradise that first year that I became intrigued with avalanche lilies that couldn't wait for winter's snow to melt. The picture I took with my primitive camera was way out of focus; next year I had a better camera.

Avalanche lily (not the out-of-focus picture I took with my Box Brownie)

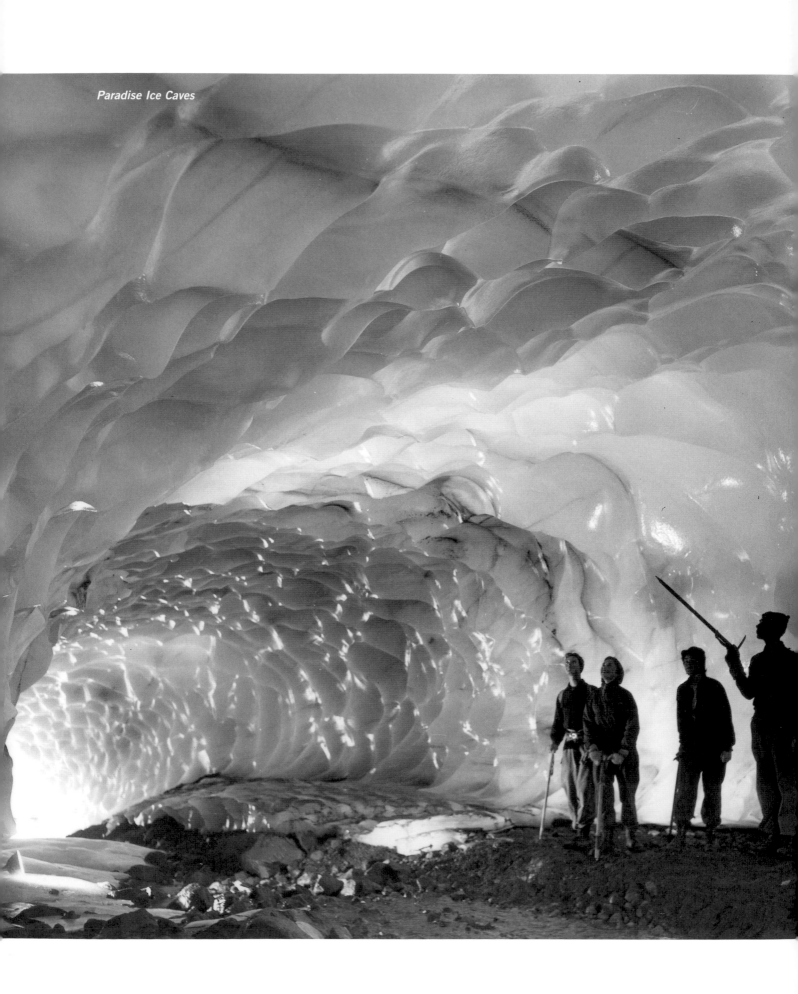

Paradise Ice Caves

Paradise Ice Caves

Mount Rainier

When I worked at Mount Rainier, there was a one-story photo shop tucked

between the Paradise Ranger Station and the Guide House. The summer of 1941, the

company was so desperate for help that, thanks to my high draft number, they hired

me to manage the shop, assisted by another photographer and two salesgirls. The

building was just big enough for a sales area, work area, and darkroom. The equip-

ment consisted of ancient, heavy wooden 5x7 view cameras that sat on heavy tripods

and had to be focused on a ground glass under a dark cloth.

No point-and-shoot with those monsters!

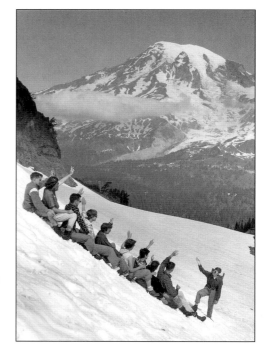

The Rainier Guide Service led tourist parties to the

famous Paradise Ice Caves. A photographer would go along

and take pictures of the group at four prearranged spots. At

the ice caves we took our final picture, packed up the camera

and tripod, and raced back to the shop to develop the film and

make proofs from the wet negatives. When the guided party

arrived back at Paradise, the salesgirls stood ready to take

orders. The customers were so impressed by such swift service

(in this pre-Polaroid era) that the girls were kept busy.

Tin-pants sliding on a guided trip

Though the fact never was widely spread, the

Paradise Glacier retreated so far in the 1930s that the fabled

ice caves disappeared. However, caves developed in the adja-

cent Stevens Glacier, and tourists couldn't tell the difference. In the 1980s those caves

also vanished. The route to where they once were is still called the Ice Caves Trail.

That was a fun summer, 1941, and I looked forward to another; however,

shortly after Pearl Harbor was bombed, President Franklin Roosevelt invited me on

a scenic cruise of the South Pacific.

Cornice on Mount Henderson

Home Sweet Home

Olympic Mountains

By mid-May, Bob and I always were itching for the mountains. The high trails were still deep in snow, but lower trails were opening. The one up the North Fork Skokomish River from Staircase was our favorite, as it was handy to Shelton and rich in family memories. Home Sweet Home, 14 miles in, wasn't named by us but certainly could have been named *for* us.

Our packs were heavy, and we had to carry our skis 8 or 9 miles before reaching enough snow to put them on. Elk were still in the valley and chummy, what with not being bothered all winter by people. Calypso orchids were out in part, and when thin snow patches began, lots of trillium showed. Once on snow, the last miles went faster.

Mount Steel from Home Sweet Home shelter

The open front of the three-sided shelter cabin shown in the photo above was a hole in the snow, but the bunks were cozy. The campfire warmed and entertained us, as well as cooked our delicious meals. Each day we'd sortie out, this way or that, in the surrounding hills.

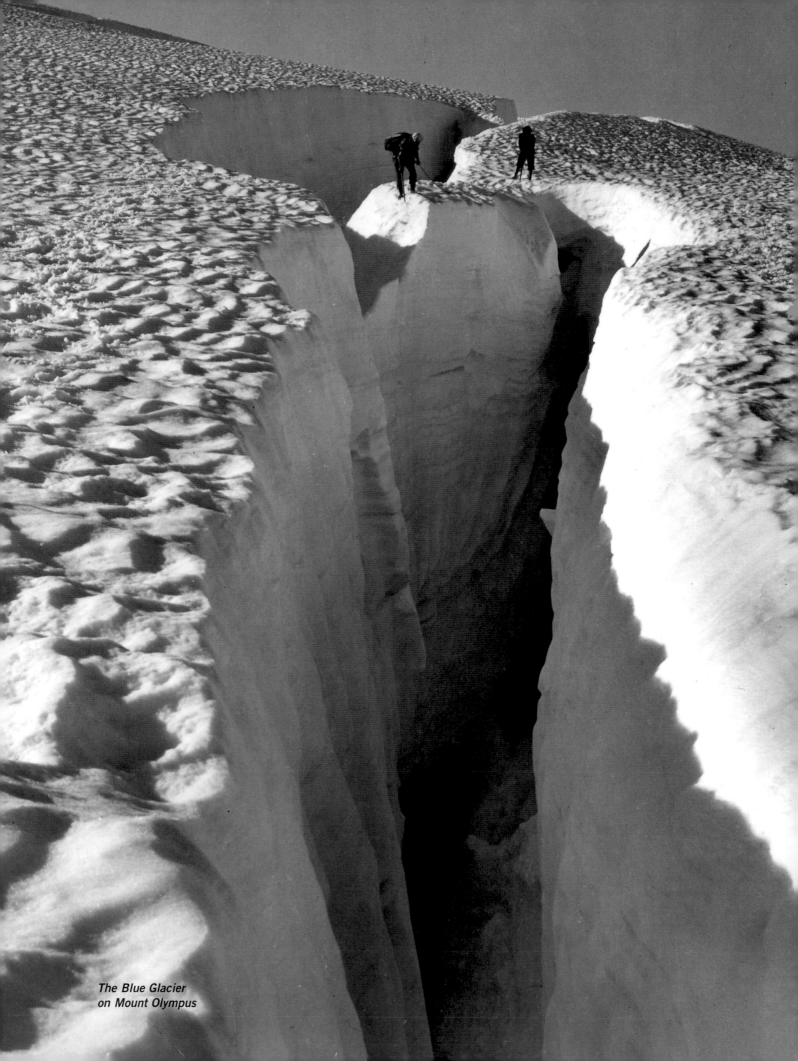

The Blue Glacier
on Mount Olympus

Mount Olympus

Olympic Mountains

In 1946 Bob, his wife, Norma, and I climbed Mount Olympus. Since there were only three of us, I had unroped to take the picture at left and presumably was straddling the same crevasse Bob was on. I shudder now to think of our running around on a glacier unroped. Fortunately, our guardian angels were keeping us alive until we got some reliable climbing instruction. Many beginners are not so lucky.

It was great fun weaving around photogenic crevasses. I do recall that the bergschrund at the top of the glacier was a bit tricky, and the final 20 feet of summit rocks were pretty hairy. You don't have to be smart to have a good climb—but it helps if you want to have very many of them.

While we were risking our necks on the peak, another serious event was occurring in camp. A bear had found our portable supermarket and was taking leisurely inventory of it, even opening a can of Dinty Moore beef stew with his teeth. Arriving at the car two days later, we were *hungry*—and had little affection for a well-fed bear.

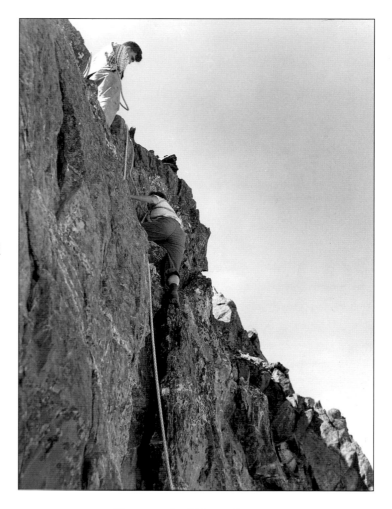

The summit of Mount Olympus

Crevasse in Mount Rainier's
Emmons Glacier

The Wonderland Trail

Mount Rainier

The Sunday Pictorial section of the *Seattle Times* ranks with Eastman Kodak's free Box Brownies in shaping our careers. In 1946 Bob and I got our first assignment, photographing the Mountaineers' Summer Outing, which circled Mount Rainier on the Wonderland Trail.

From Steamboat Prow, fifty-six of us climbed to Columbia Crest, the summit. I took this picture of Bob high on the Emmons Glacier. I was roped to somebody, but I don't remember whom.

Historically, the picture shown here of the group crossing the Winthrop Glacier is fascinating. The year was 1946. The Summer Outing, an annual tradition since 1907, still favored the mass marches of early mountaineering and, even amid the monster crevasses of Mount Rainier, was selective about where climbers had to be roped. In the prior decade ice axes had pretty well replaced alpenstocks but not entirely.

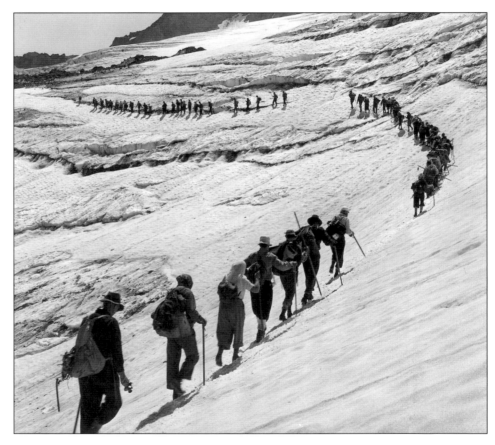

The 1946 Mountaineers' Summer Outing crossing the Winthrop Glacier

A bergschrund on the Emmons Glacier

The Mountaineers' Outing
Mount Rainier

The *Seattle Times* had given Bob and me the assignment of photographing the 1946 Mountaineers' Summer Outing; that paid our out-of-pocket expenses. The profit came from Eastman Kodak, which liked the picture below so well they bought exclusive rights and displayed it in camera shops across the nation. I made the photo on the left, of my brother, beneath a bergschrund about 500 feet below the summit of Mount Rainier.

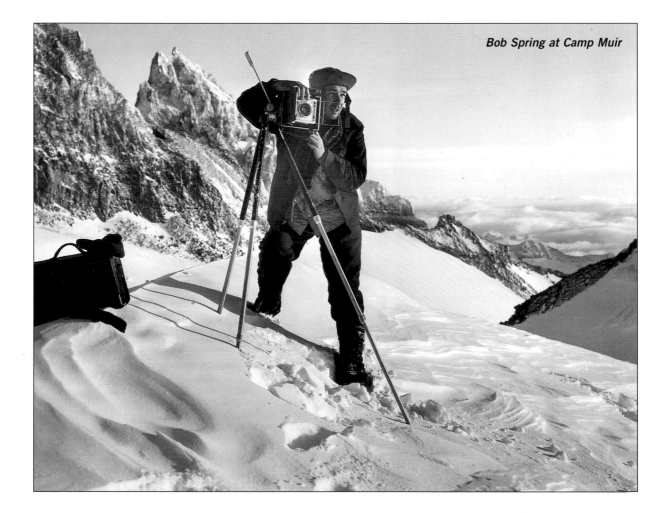

Bob Spring at Camp Muir

What do mountain guides do for fun on their days off?

The Nisqually Glacier

Mount Rainier

The photographs on these two pages exemplify my fascination with shapes and lighting found on a glacier. Lighting can make or break a picture, and it is most important for snow to have cross lighting.

Bob Craig, a guide at Mount Rainier, spent a day having fun on the Nisqually Glacier, and I went along. I spotted the picture at left in the morning, but the lighting was all wrong. I made certain to go by that serac on the way home and found the lighting then to be perfect.

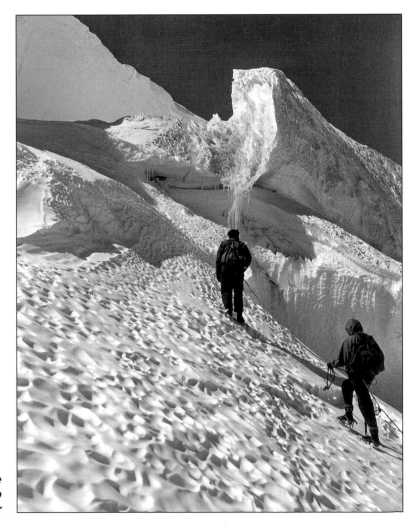

A lucky shot I took in the early morning on a climb of Mount Rainier

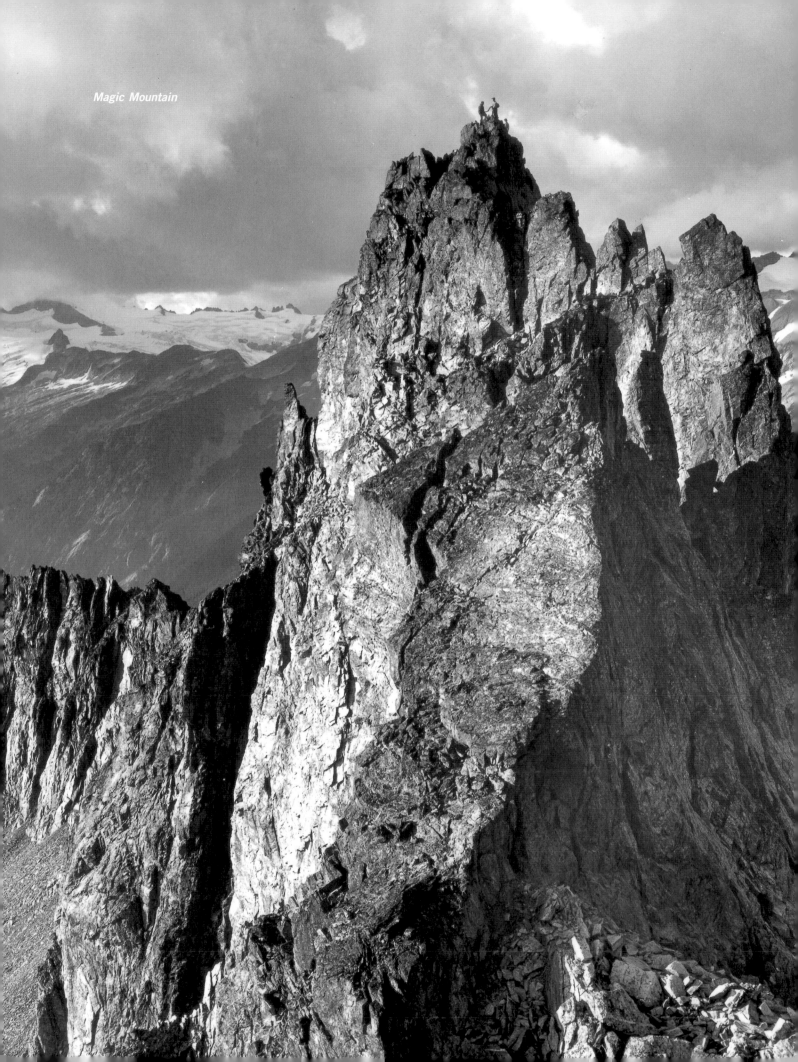

Magic Mountain

The Ptarmigan Traverse
Glacier Peak Wilderness

In 1958 I led the third party to do the Ptarmigan Traverse for a story in the
Saturday Evening Post. This high alpine route is the most popular in the Cascades.
It begins at Cascade Pass, winds southward through stunning mountains, and ends
at Downey Creek, just north of Glacier Peak. The picture at left suggests an idyllic
jaunt in the sun. The grim reality was that in two
weeks we had only three sunny days—and this
wasn't one of them.

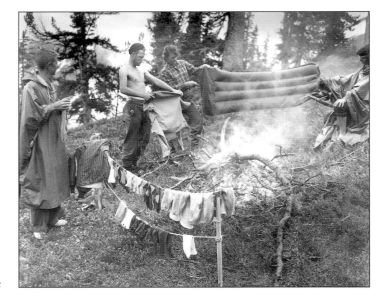

Drying out after five days of steady rain

My Ptarmigan Traverse story in the
Saturday Evening Post was titled "Learning the
Ways of the Mountains." We surely did experi-
ence many of the ways of rain and fog, but not
much that we didn't already know. At that time
there were no accurate USGS maps. We did have
the advantage of knowing the Ptarmigan Traverse
had been done twice before us, but we didn't
know the exact route previous parties had taken.
At any rate, we were taking a mostly new route. Because of that knowledge (or lack
of it), I allowed two weeks for the trip to make sure I had enough time for plenty
of pictures. Well, there are limits to what can be done photographically with fog.
I suppose we should have appreciated the advanced course we got in routefinding
when we couldn't see the route and when the maps, made before the era of aerial
photographs, were based on eyeball guesses.

The climb of Magic Mountain from a camp at Kool-Aid Lake was taken on
the first clear day of the traverse. We were only the seventh party to sign the sum-
mit register.

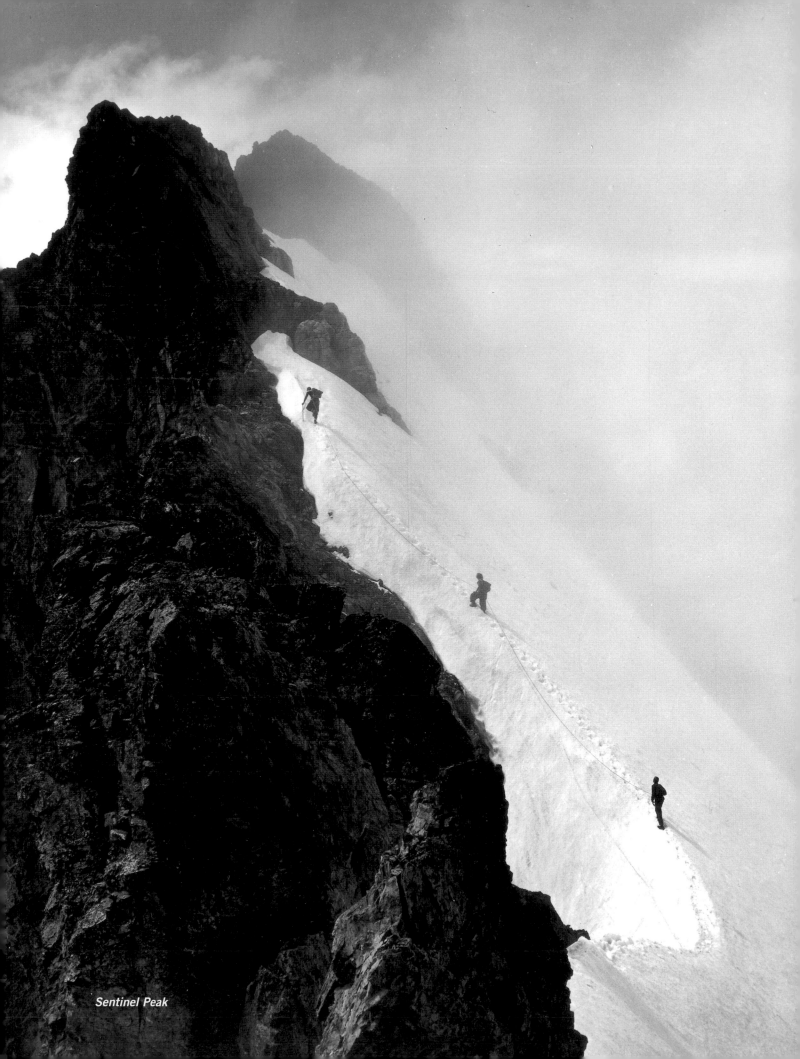

Sentinel Peak

A First Ascent

Glacier Peak Wilderness

Rain and fog, rain and fog . . . and more rain and fog. What a miserable way to enjoy the beauties of the Ptarmigan Traverse.

We camped in the fog two nights on the Le Conte Glacier, a thousand feet below the 8,261-foot summit of Sentinel Peak. Boredom caused us to fumble up through the fog to the top, expecting a summit register that would tell us exactly where we were. Nothing.

Back at our tents, we saw through a hole in the fog our footprints heading to the wrong summit. We set out once more. The fog closed in, but this time there was a register, signed by eight people who knew where they were, and therefore so did we. We named the first peak, which we had climbed accidentally, the Peg, after our youngest member, Peggy Stark.

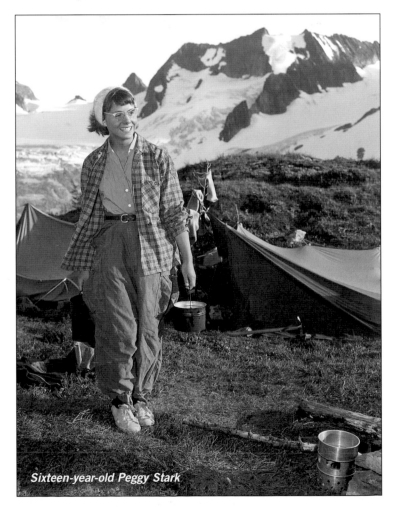

Sixteen-year-old Peggy Stark

White Rock Lakes and Dome Peak

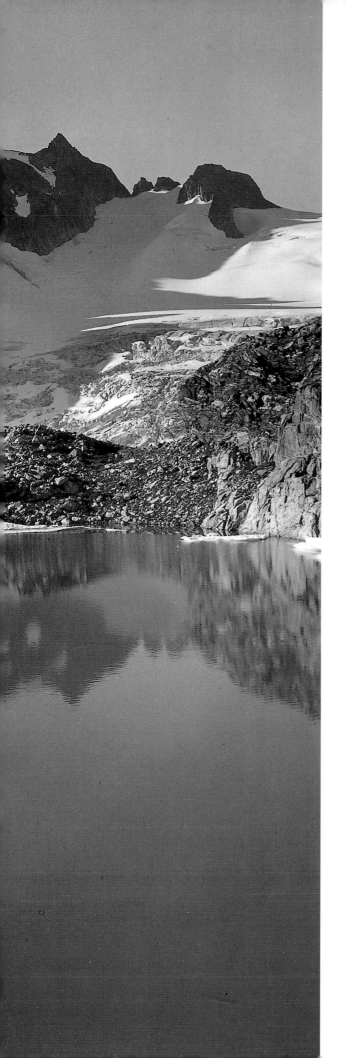

White Rock Lakes

Glacier Peak Wilderness

The view from White Rock Lakes across the huge, deep hole of Agnes Creek's West Fork to Dome Peak, rising between the Chickamin and Dana Glaciers, is, in my opinion, the most spectacular in the Cascades. It certainly is the climax of the Ptarmigan Traverse. Considering we had only three days of sunshine on the whole trip, we were lucky to have two of them here.

The lake basin was still filled by a glacier when the Ptarmigan Climbing Club pioneered the traverse in 1938. The second traverse, in 1953, found the lower lake melted free and named it for the nymph pictured on bottles of White Rock Sparkling Water. A large flat rock at the outlet would be a perfect place to come upon a scantily clad young lady.

We were fortunate to get a clear day to study our planned route, unlike those previous days when we'd been in fog so dense it hardly paid to keep our eyes open. We decided to circle around the Dana and Chickamin Glaciers, take a side trip to the summit of Dome, then traverse the Hanging Gardens toward Image Lake. I hate to think of how spectacular an adventure we would have had on those glaciers without the fog.

*Dana Glacier on Dome Peak
and a deer near White Rock Lakes*

Return to White Rock Lakes

Glacier Peak Wilderness

In 1970 my wife, Pat, and I spent four days photographing a glacier research team on the South Cascade Glacier, a hop, skip, and jump from White Rock Lakes. The weather was just what it ought to be, so we did what we had to do—we headed for the lakes. The day we spent there made up many times over for the time in 1958 when I had such terrible weather.

Late in the afternoon, with just one color film and one black-and-white film remaining, I spotted a ptarmigan, precisely in position to be a picturesque foreground for Dome Peak. I squatted to the bird's level to focus and was about to snap the shutter when someone walked through my view. I started to stand up to say a few harsh words to whomever, lost my balance, and fell back to the ground. That was no someone, that was a buck—a noble beast for sure. My falling down spooked him into a run, but he didn't go far. He paused to check me out, which was long enough for me to shoot my last color film. He ran a bit farther while I switched to black-and-white film but stopped for another look, and then he was gone for good. Two weeks of rain and fog on the third traverse may have been deserved punishment for whatever sins I might have committed, but since then I evidently had lived right. Both exposures were perfect.

Bergschrund on Cache Col

Carol Marston, one of my
teenagers, on the Cowlitz Glacier

My Teenagers

Mount Rainier

Don't do it!

Don't take two teenage girls and two teenage boys on a camping trip. When I announced my intention to do so, I was warned. Bob's wife, Norma, who had chaperoned high school parties as a teacher, told me horror stories. Well, I was sure I knew some teenagers who were different.

The typical climber only has eyes for the top and is very cool toward a photographer fussing about finding exactly the best camera platform and fiddling with lenses. In the

Teenagers Dave Nicholson, Gary Rose, Joan Marston, and Carol Marston

1950s our customers insisted on 4-by-5-inch color film, which means a big camera and lengthy focusing. Moreover, in climbing situations the safety of the photographer as well as his subjects has to be considered. Getting a good story from a regular climbing party just hardly ever happens.

In 1951 I spotted teenagers from a climbing course eager to go climbing but short of transportation and leadership. Checking them out with other instructors in the course, I settled on sisters Carol and Joan Marston, David Nicholson, and Gary Rose.

We spent a week on Mount Rainier, mostly above Camp Muir, and climbed to a series of photogenic locations. They were always eager for more and never complained. Well, almost never. After a week of canned corn beef and dehydrated vegetables that never rehydrated and wouldn't cook, a few murmurs were heard. Over the course of three years, these marvelous teenagers helped me on several magazine stories, and Bob and I featured them in two movies.

Two of my teenagers exploring the Cowlitz Glacier

Reunion of My Teenagers

Mount Rainier

All too soon, my teenagers weren't teens anymore. They had jobs and moved on with their lives. Other great teenagers were lured by my delicious peanut butter sandwiches, but the first four were . . . well, they were the first. Recently we got together for a fifty-year anniversary party. My teenagers now have gray hair, are retired, and are on Social Security. I finally heard a really serious complaint about those good old days. Gary or Dave—I can't recall which—said that since then he has never touched corned beef.

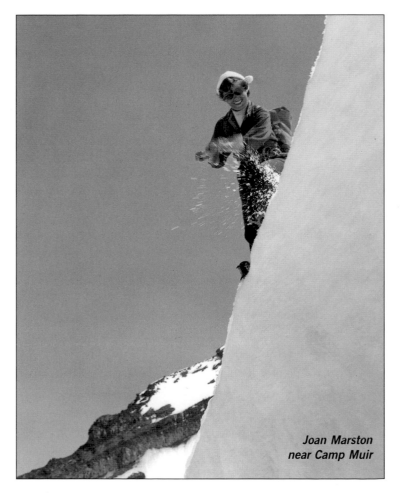

Joan Marston near Camp Muir

A cave in the Emmons Glacier

A Glacial Wonder

Mount Rainier

In 1955 my second generation of teenagers and I camped for a week in the saddle between the Ingraham and Emmons Glaciers, looking for ice formations the camera would love. I was enchanted by a grand cavern formed when glacier motion squeezed a crevasse shut and pressed its upper edges together.

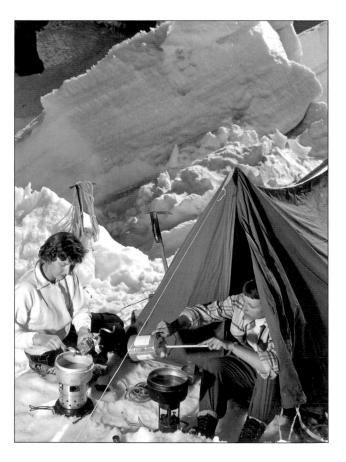

My second group of teenagers, camped on the Ingraham Glacier

Air view of the crater and Columbia Crest, the highest point of Mount Rainier. The tiny line of dots are climbers nearing the top.

Crater Camp
Mount Rainier

The Mountain is 14,410 feet high today, just as it was in the 1950s, and the glaciers are just as wide and the crevasses just as deep. Above 10,000 feet or so, now just as then, the average person finds the air thinning to a condition where he or she must take a step, a breath, another step and breath, another step and perhaps a couple of breaths, another step and several breaths, and so on, with occasional time out for someone sick from exhaustion.

Camping in Mount Rainier's steaming crater

The difference between now and the 1950s is the population explosion. In the 1950s as many as 300 individuals attained the summit in a year; now there are often that many in a single day. Those black dots in the aerial picture at left are not ants; they are some of the people who signed the register that day.

I wanted to do a story on a night in the crater. We set up tents on steam-warmed rubble of a far-from-extinct volcano. Although the tent was covered with frost in the morning, we were comfortably warm all night.

The Hourglass on
Mount Shuksan

A Climb on "Spec"

North Cascades National Park

A story I did about a climb of Mount Shuksan on "spec," meaning no prepaid assignment, proved gratifyingly profitable. The *Seattle Times* used it first, then *Esquire,* then *True,* and, two years later, *Esquire* again. The photograph on the left surely was a selling point. It was taken on the Hourglass, a steep shortcut from Hell's Highway on the Curtis Glacier to the Sulphide Glacier and summit pyramid. The picture was a lucky one; I was leading the second rope when I looked ahead and saw the climbers with a background of evil-looking clouds.

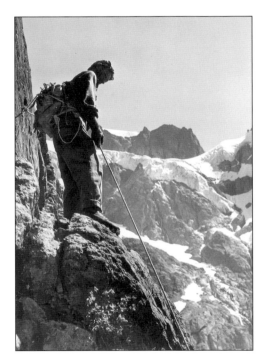

John Klos belaying in Fisher Chimneys

Yes, those clouds. Evil enough. They'd rained on us for five days at our Lake Ann camp. We were running out of food and time and were packing to go home at eight o'clock in the morning when a hole opened in the sky. It was several hours late for a proper start, but we went anyway. Above Fisher Chimneys the clouds rolled in again, but we continued through them to the top. What was that pink look to the fog? Sunset colors! Not what you want to see on the summit of Mount Shuksan.

We hurried down the Sulphide, Curtis, and White Salmon Glaciers to Fisher Chimneys and gazed into night too total for the steep and tricky scramble down. The five of us huddled together against a big boulder, where we spent a long, cold night. The clouds gave up, the sky cleared, and the stars were amazing. A vertical mile below our toes, the lights of Mount Baker Lodge spoke of guests roasting chestnuts and toes by the fireplace.

Too bad Pat and I weren't yet married. By today's rules, of course, we'd have been allowed to snuggle. But that was then, and (aside from our upbringing) we had three chaperones just waiting for us to make a false move.

Little man what now? Fred Beckey stemming below a chockstone in the Enchantment Lakes region

Fred Beckey

Alpine Lakes Wilderness

Fred Beckey made his initial first ascent in the 1930s when he was a precocious fifteen-year-old. By the 1970s he had set (probably) a record for firsts in the United States and Canada; most were extremely serious stuff on rock and ice. Aside from being among the earliest "world class" climbers in North America, he is the foremost historian of wilderness mountaineering in the Northwest ranges. His climbing guides to the Cascades, which began in 1949 with *Beckey's Bible,* have been judged the very best such guides in the world, including the Alps.

A thing I personally appreciate in Fred is that—a rarity among climbers of his talent—he would take time from a climb to help a photographer. He even made a side trip to show me the dramatic chockstone at left in the Cashmere Crags of the Enchantment Lakes region. Then, that I might share in a first ascent, he literally hauled me up a *very* small, *very* sharp peak he named Tulip Tower.

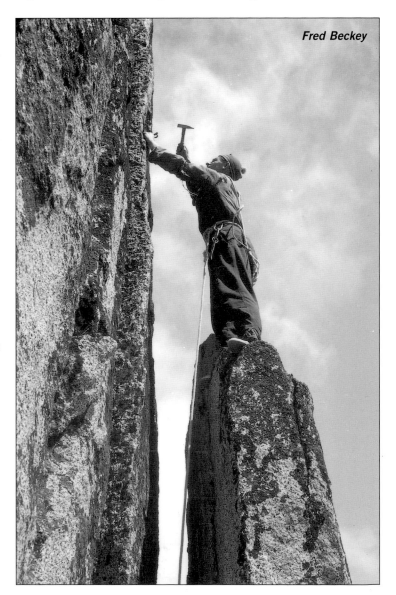

Fred Beckey

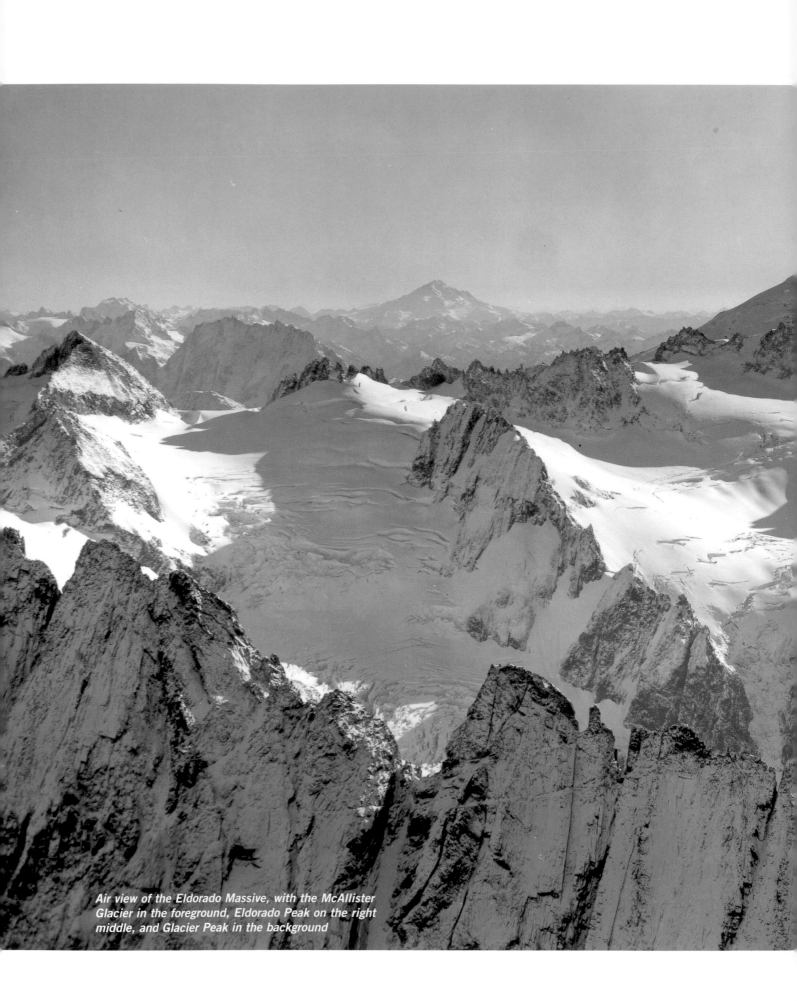

Air view of the Eldorado Massive, with the McAllister Glacier in the foreground, Eldorado Peak on the right middle, and Glacier Peak in the background

Aerial Photography
North Cascades National Park

In 1968 I bummed a helicopter ride with the soon-to-be first superintendent of the brand-new North Cascades National Park. For Roger Contor it was an introduction to the wilderness that would be in his charge. For me it was a chance to see in a few hours the places I'd been hiking to, and around, for years—and do it sitting down. We made a big loop around the Pickets, over Ross Reservoir, up Thunder Creek, and down the Cascade River.

The cramped quarters and plexiglass windows of the helicopter gave the camera little room for action. A week later I hired a Piper Cub to review some of the highlights, as in the scene shown here. The Piper Cub, the "Model A" of 1950s airplanes, was an ideal camera platform. The windows and doors were hinged for easy opening and its 60 mph cruising speed gave me time to think, although downdrafts and updrafts still made it hard to line up shots. The pilot made a half dozen passes before I got this one right.

Few Piper Cubs now survive outside flight museums. Its successor is the small Cessna that has a little window that opens and a door that can be taken off —if the pilot is willing to fly while succumbing to hypothermia.

Having explored this area in years past, I was delighted to pick out landmarks I knew. There is an amazing difference between an air view and a view from the ground, even from summits. Flying over a mountain can be impressive, briefly, but there is not the feeling of being "connected" one gets on the ground after a difficult climb. My friend Harvey Manning is vehemently opposed to air views, believing they are strictly for birds and God and feeling that man has to see nature with both feet on the ground.

*The Unsoeld Family
on Mount Eldorado*

Willi Unsoeld

North Cascades National Park

I first photographed Willi Unsoeld when he was a climbing guide in the Tetons. When he attended the University of Washington, we saw a lot of Willi, his wife, Jolene, and their four children.

Willi was a philosopher and a spellbinder, with amazing insight into social and environmental problems. Later, at Evergreen State College in Olympia, Washington, he was a charismatic teacher. Willi was an internationally famous mountain climber who, with Tom Hornbein, made the first ascent of the West Ridge of Everest, at the time the most technically difficult climb ever made in the Himalayas.

In 1973 Willi agreed to let me do a family story of the Unsoelds in the North Cascades. The peak I chose, Mount Eldorado, was easy enough to allow time to get acquainted with the whole family. Devi, his daughter, especially impressed me. She adored her father and shared his visions of the social and environmental future our nation should seek. She might have been the first woman to be U.S.

Devi and her father, Willi Unsoeld

president, had she not died tragically on the Himalayan mountain she was named for, Nanda Devi. Willi was killed in an avalanche on Mount Rainier.

Jolene ran for Congress and spent four years in Washington, D.C. In a chance meeting I got the only hug I ever had from a congressperson in the sacred hallways of the Capitol.

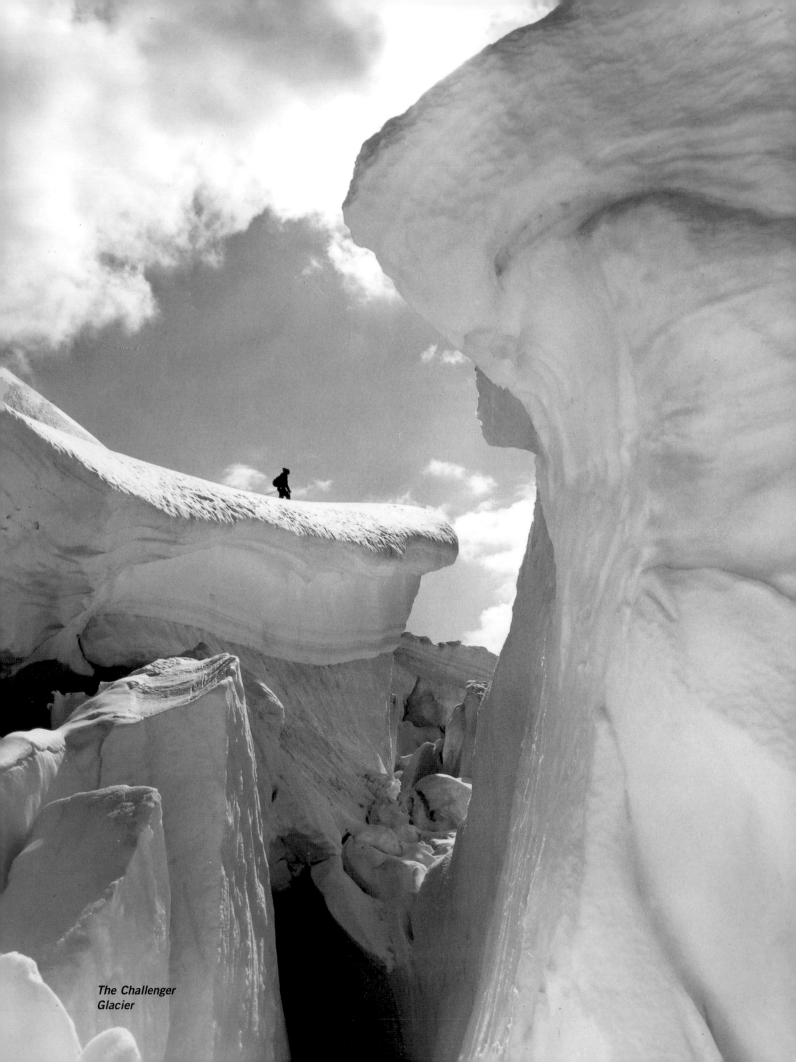

The Challenger
Glacier

Mount Challenger

North Cascades National Park

National Geographic magazine asked Bob and me to illustrate a story being written by Supreme Court Justice William O. Douglas to promote creation of North Cascades National Park. "Why us?" we asked, "when you have so much talent on staff?" They answered, "None of our guys are willing to sleep on the ground."

We, of course, were overjoyed at the opportunity to explore the Picket Range, since not many assignments would pay us to pack the 17 miles to Whatcom Pass and spend a day there in the rain and fog. The third day we traversed under clearing skies around Whatcom Peak and climbed over a badly fractured glacier to a camp on the side of Mount Challenger, highest of the Pickets. From here the summit climb was short, allowing plenty of time for photographs.

Camping below the Challenger Glacier

Back at camp we were perplexed by brand-new boot prints in the glacier. Famous as the area was to become after creation of the park in 1968, it was so lonesome then that we hadn't seen a soul in three days. Where had the prints come from? They started in the snow. Flying saucers? While we were preparing supper, the mystery was solved. Two geologists, making a survey of the mineral potential required by Congress before it would consider the park proposal, came down from the peak loaded with rock samples. Almost instantly a helicopter arrived to whisk them away to restaurant meals and cozy motels. The *Geographic* guys never would have had to sleep on the ground.

Air view of 8,000-foot Phantom Peak and the unnamed glacier on the side of Luna Cirque

Luna Cirque

North Cascades National Park

Okay, I cheated—the camera and I were in an airplane for the photo at left. On foot it took us ten days to get to and from one of the "deepest, darkest holes in the North Cascades," the Luna Cirque in the Northern Pickets. I'd done that and had filled my eyes. While the air view is spectacular, the face-to-face view—looking at the nameless glacier tumbling down the headwall from 8,000-foot Phantom Peak—was much more impressive from the rocky ledge we had climbed to, as the photo below shows.

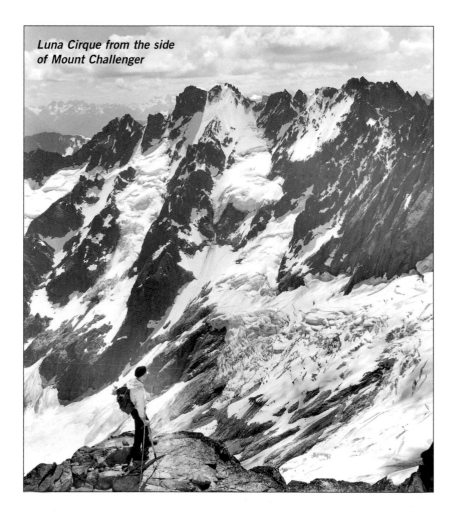

Luna Cirque from the side of Mount Challenger

*Jim Whittaker jumping a crevasse
in Mount Rainier's Cowlitz Glacier*

Americans on Everest (and on Mount Rainier)

Mount Rainier

Bob and I are fraternal twins, but we have little family resemblance. Jim and Lou Whittaker, however, are identical twins. The only differences between them, that I know, is that one is left-handed; the other is right-handed and has a small mole under his left ear. You can forget who is who if you are lost in the mountains, for they are both supremely skilled. As little kids they had fun tricking their mother and, later on, mystifying their girl-friends. From the time they were teenagers, they've been more than helpful to a photographer (me) who asked them to walk miles out of their way and climb walls of rock or ice.

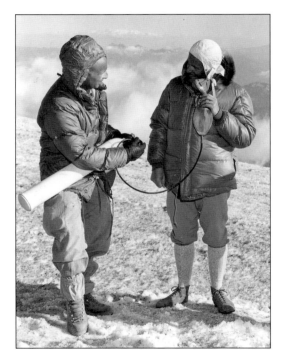

Checking oxygen equipment to be used on Everest

Both Jim and Lou were recruited for the 1963 expedition to make the first American ascent of Mount Everest. The party was very strong, but we Puget Sounders were confident the two would make the top arm in arm, just as they did on peaks at home. In the end it turned out that Lou's employer wouldn't let him off that long; however, Jim's boss at REI (Recreational Equipment Inc., or "the Co-op") considered his time on an expedition a good company investment. So only half the twins became the first American on the summit of the world.

Jim's most important contribution to the expedition was as equipment manager, for which his REI experience made him invaluable. I didn't go anywhere near Everest, but I did a newspaper story on the training session at Camp Muir on Mount Rainier. As Jim later asserted, conditions on Rainier are in many ways very much like those in the Himalayas—the weather extremes, for example.

Ice cliff on Mount Rainier's
Cowlitz Glacier

Lou Whittaker

Mount Rainier

"Lighting! Lighting! Lighting!" says the photographer of snow and ice.

In 1970 I was working with Lou Whittaker and his Rainier Mountaineering Guides on an advanced photography/climbing seminar. On the last day the guides took the clients to the top. That gave Lou and me a spare day at Camp Muir to roam the glaciers. Lou roped up with one of his guides; Lou's wife, Ingrid, and I were the other rope team. The lighting was perfect on this ice wall, at left, but it seemed to me too steep to climb. Said Lou, "No problem." He swung his ice ax and cut a few steps to a small ledge, belayed his partner up, and cut a few more steps to the left skyline. No problem for the likes of Lou!

Step cutting

Inside a
bergschrund

A Test

Mount Rainier

At the 1970 photography/climbing seminar, Lou Whittaker wanted to test the newfangled ice screws that had replaced the ancient (and useless, in my opinion) ice pitons. I wanted a scene the camera would appreciate. The two requirements weren't really compatible.

I picked the spot; Lou said the ice screws wouldn't work, but he twisted in the first one anyway. It held his weight, as I knew it would. He stepped up and put in a second screw. It held. Third screw, all okay. Onward and upward! The fourth, still going strong. The fifth one and reaching for the sixth when Lou proved he was right. Out came the screw, and plunk, plunk, plunk, plunk, down came Lou, ice screws and all. He landed in soft snow. However, I got my picture, so a good time was had by everyone.

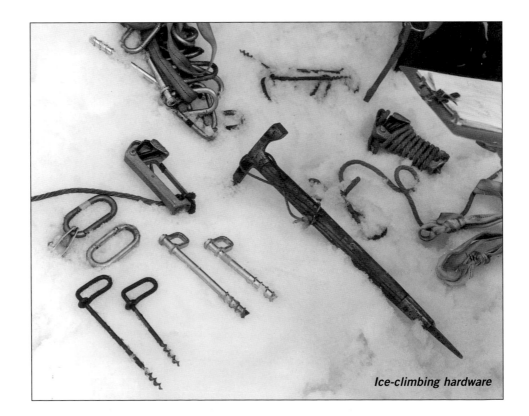

Ice-climbing hardware

Sunrise on the Cascade Mountains from Camp Muir, the Tatoosh Range, Goat Rocks, and Mount Adams in the distance

Serendipity
Mount Rainier

You shiver out of your sleeping bag at midnight, fumble into parka and boots, gag down a cold breakfast, strap on crampons, hoist your rucksack, tie in with your rope team, and step out on the glacier, still by flashlight. That's what a summit climber has to do on Rainier in order to climb to the top and get back down to high camp before the snowbridges over crevasses get creaky.

A photographer of ice formations, on the other hand, wakes up when the climbers leave, makes a few smart remarks, and goes back to sleep until broad daylight.

In 1970 I was doing a photo seminar with the Guide Service at Camp Muir. Rather than sack out in the dormitory with the exhausted clients who were snoring and talking in their sleep, I slept on the flat roof of the guide hut. The climbers moaned and grumbled as they rolled out at midnight; I smiled and slept on. Opening my eyes at sunrise, I came wide awake instantly. I reached for my pack, opened my view camera, set it on the roof beside me, and got this photo at left while still in bed.

Camp Muir and the Cowlitz Glacier

Eastman Kodak enlarged the film to an 80-foot-wide backlit color transparency for a display in New York's Grand Central Station. Friends returning from a trip East called me at home to tell me how thrilled they had been to see a bit of home in New York.

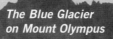
The Blue Glacier
on Mount Olympus

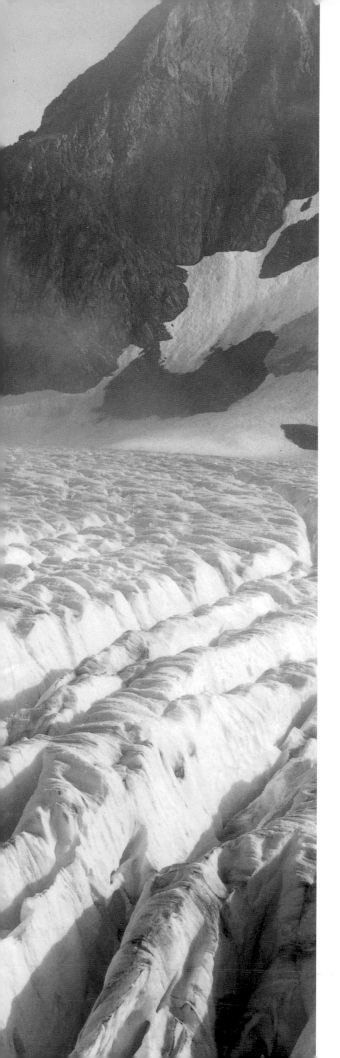

The Blue Glacier

Olympic National Park

The snout of the Blue Glacier on Mount Olympus fractures into myriad crevasses as it prepares to tumble over a cliff to the lower valley, headed for the Hoh River. While exploring the three peaks of Mount Olympus, we camped three nights beside the ice. Our water supply was from meltwater streams on the glacier's surface.

On sunny days the glacier surface is sparkling-clean white. In evening, though, and on dark rainy days, the snow comes alive with millions of squirming ice worms that rise from the cold depths of the glacier to dine on whatever an ice worm considers tasty. We wondered how much protein we were getting in our morning cocoa. A novice climber ordinarily scoffs at what he thinks is a myth until, quenching his thirst by sucking a snowball, he sees a little black worm, almost an inch long, wiggling in the snow he is holding.

Ice worms living in the Blue Glacier

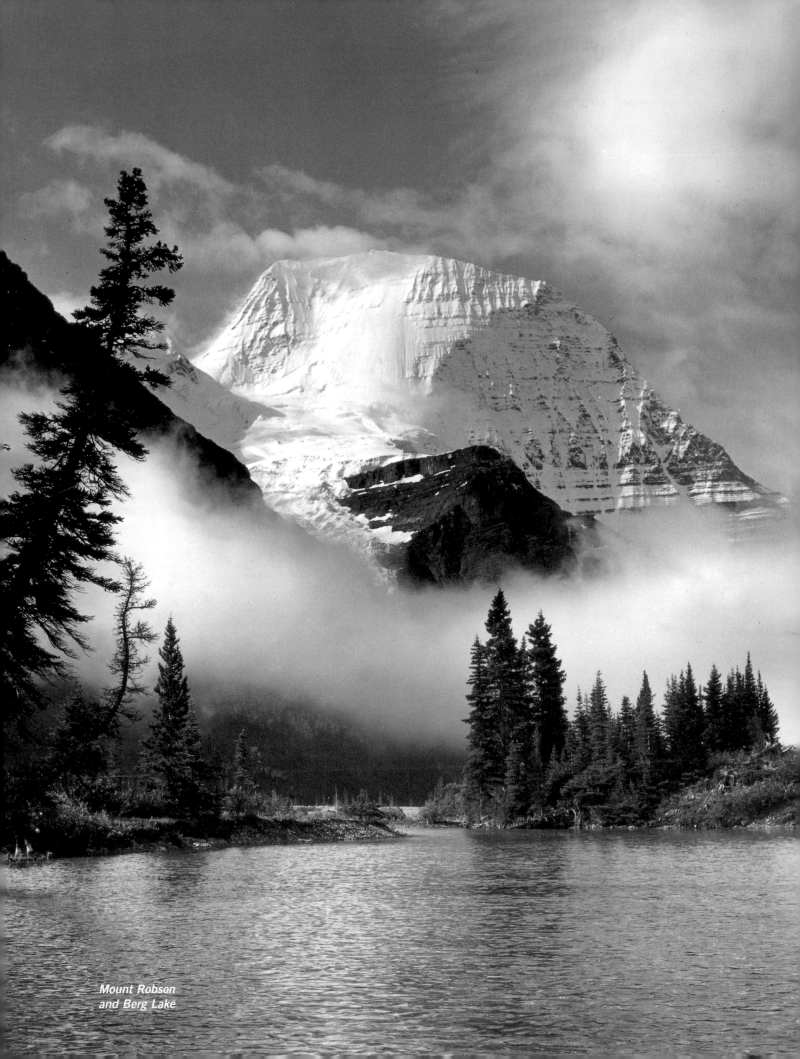

Mount Robson
and Berg Lake

Berg Lake
Canadian Rockies

In 1950 I photographed the summer outing of the Mountaineers at Berg Lake. Pat was four months pregnant, and the trip leader, a bachelor, was distraught when he saw her "delicate condition." To her disgust he required her to accompany the "old folks," who were taking two days to walk the 11 miles. It was a good thing (for the old folks) that she did, because they never would have made it over the shaky bridges without her helping hand. As for Pat and son-soon-to-be John, they waded the icy torrents while holding out a hand for the elders on the bridge.

I was with the group of climbers who attempted Mount Robson, highest peak in the Canadian Rockies. Though the peak was attempted every year,

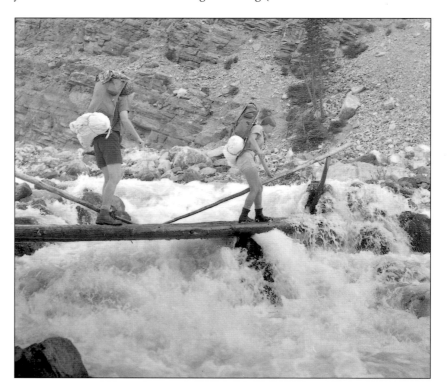

Crossing another glacial torrent on the trail to Berg Lake. Pat, four months pregnant, waded the cold water, helping others across.

no party had reached the top in a decade or so. We tried twice but both times were weathered out at high camp. Looking up at what we faced if good weather had forced us to carry on, I was just as happy. On the way out from Berg Lake, Pat refused to do convoy duty; she, along with John, hiked out in a single day. Two other climbers were assigned to do the icy torrents and provide the helping hands.

Mount Robson and the Berg Glacier flowing into Berg Lake

Return to Berg Lake

Canadian Rockies

On the Mountaineers' summer outing in 1950, I took some great black-and-white photographs but didn't take any color. That gave Pat and me a good excuse for a return trip with color film twenty-five years later. The bridges over glacial torrents were a bit more secure, but still nothing to make "old folks" content.

We spent a day exploring a new trail that follows the Robson Glacier to Snow Bird Pass and then Robson Pass, famous for trilobite fossils.

On the way back, only two days later, where the Robson River flattens out in a braided pattern above Kinney Lake, we came to a channel with no river, just a bridge over dry gravel. Then we came to the new channel, this one with no bridge but glacier melt up to our knees. Invigorating!

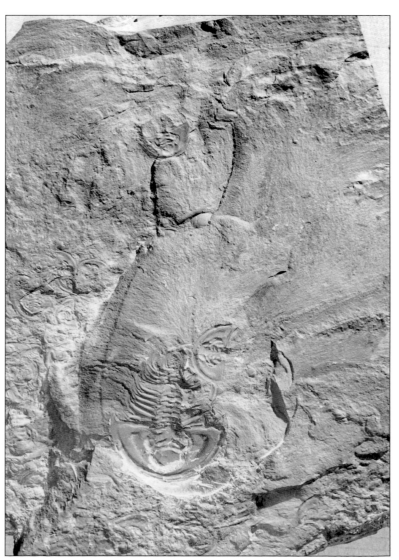

Trilobite fossils found at Robson Pass

Assiniboine Lodge, Lake Magog, and Mount Assiniboine

Magog Lake
Canadian Rockies

Assiniboine Lodge was built some seventy years ago by Earling Strom, a New Englander who climbed major peaks all over the Canadian Rockies. He concluded that Magog Lake was the place to settle down.

Winter outing at Assiniboine Lodge

I first visited in 1952 on a winter outing of the Alpine Club of Canada. The weather outside was frightful, but the fireplace was delightful. I've returned twice for summer pictures of Mount Assiniboine, known as the Matterhorn of Canada. On a summer trip I briefly met Strom—running out to take in his laundry! He said my big camera and heavy tripod meant I must be a professional, and he wanted the lodge to look its best.

The campsite located apart from the lodge is one of the greatest backpacks in the Canadian Rockies. At 17 miles from the nearest road, it's anybody's definition of "deep" wilderness. Or it used to be. Nowadays, twice a week a helicopter unloads tourists in tennis shoes and crispy clean vacation-casual garb. Fortunately, they tend to trot immediately into the lodge for tea, leaving the wilderness for those who want to work a little for it. Views out the windows are good enough for them.

Lake of the Hanging Glacier

Lake of the Hanging Glacier

Canadian Rockies

In the Canadian Rockies I love Magog Lake's reflection of Mount Assiniboine and the icebergs in Berg Lake from the glacier on Mount Robson. And, I have to admit, I love the foreground of Lake Louise with its background of Mount Victoria. But Lake Louise . . . I lost count of the walkers along its shore somewhere after a thousand. On the trail up to the Plain of Six Glaciers, I tallied some 500, speaking a dozen languages. More power to 'em. Everyone's gotta be someplace, and in my opinion you run across a better class of folks in the mountains.

However, my favorite Canadian lake isn't in the Rockies but in the Purcells. The gravel roads there are pretty much shunned by tourists in favor of the paved Banff-Jasper Highway. Free maps are available from the Ministry of Forestry; trust them and not the road signs, and you'll find ten good hikes on the east side of the range. I've done five of them.

Lake of the Hanging Glacier called me back. Eighteen years before, Pat, my daughter Vicky, and I had an easy 4½-mile hike in, and from the lake we climbed another 500 feet up a ridge for the overview. Well, something had changed drastically in eighteen years. I found the trail was much steeper, had more roots and boulders in the tread, and seemed a lot longer. Perhaps I had been more chipper at sixty-two than now, at eighty. Five or six groups of young folks passed us by as though we were standing still. So maybe the trail and I both weren't what we used to be. The lake was, though.

Building an igloo on the Columbia Ice Field, with Mount Columbia in the distance

A Photo Assignment

Canadian Rockies

Our favorite drink is mountain water, but Bob and I did have fun with Canadian Club whiskey. In the process we paid a whole lot of rent back in those early years when we never made enough money to even file income tax returns.

Crevasse-jumping was our theme for this ad—as reliable as rappelling, in our bag of tricks. We skied 8 miles up the Athabasca Tongue of the Columbia Ice Field, hydrographic apex of North America, with meltwater flowing to the Atlantic, Pacific, and Arctic Oceans, and made camp at the Snow Dome. The next day we scouted around for a crevasse that our subject, Walt Gonnason, could jump and that would provide me a safe place to work my 4x5 view camera.

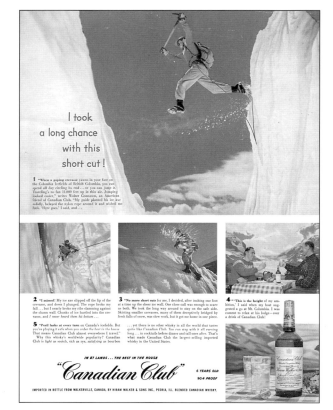

An ad in Life magazine

We found a dandy 6-footer that gave Walt's long legs a good stretch. We had him do a dozen jumps to ensure that I got at least one good film.

The disappointment was having to work so hard (Feel our pain!) that we lacked enough time to properly soak up scenery. Close by our camp were several fine peaks, including Mount Columbia, which looked as though it would have been an easy day's ski.

Scimitar Glacier on 13,177-foot
Mount Waddington, highest peak
in British Columbia

A Stamp of Approval

British Columbia

We were happily surprised in 1997 when a Canadian postage stamp was issued honoring Phyllis Munday, whom we had met when she worked in Banff at the office of the Alpine Club of Canada. One winter we were in a group with her for a ski week at the club's Wheeler Hut, near Rogers Pass in the Selkirk Mountains.

Wilderness mountaineering, as distinguished from alpine craft, wall climbing, icicle climbing, or bouldering and such, is the sport (or whatever) of the Pacific Northwest, and none of its pioneers are more illustrious than were Don and Phyl Munday. From afar on Vancouver Island, they spotted a peak they called Mystery Mountain. In 1925 they set out from their home in Vancouver in a little kickerboat to find the mystery—no simple task amid the maze of fjords penetrating the British Columbia Coast Mountains and the unmapped and unnamed glaciers flowing from ice fields nearly to tidewater.

Relay-packing through rain forest jungles

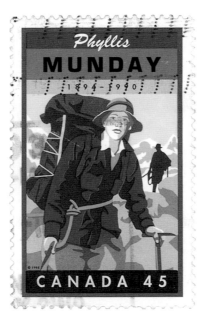

Phyllis Munday

and across glacial torrents simply to reach the glaciers took many days. So where *was* this Mystery Mountain? In 1934 they at last found and climbed the West Peak of 13,177-foot Mount Waddington, as the government named it, and in the search made first ascents of many other peaks, including the one named for them.

I don't know any wilderness mountaineer who doesn't hold the Mundays in awe or envy them for the luck of living when they did, when the wildness of wilderness was not diminished by aircraft. ("The past is a foreign country. They do things differently there.") Alpinists now can skip over the formidable difficulties faced by the Mundays. Even so, the peak is difficult, the weather is terrible, and ascents are few. Nobody since their time has attempted to repeat their adventures from sea level.

In 1948 Don Munday's book *The Unknown Mountain* was published in England; it was reprinted in the 1970s by the Mountaineers.

*Seracs on the
Ingraham Glacier*

Crevasses
Mount Rainier

From the air the crevasse patterns on large glaciers, such as those on Mount
Rainier, are a fascinating expression of the flow mechanics of ice. For climbers on
the surface, they pose an intellectual challenge, sort of a chess game, finding a route
that doesn't lead to a dead end. Climbing routes on Rainier follow rock cleavers as
much as possible. The volcanic stuff of the mountain is no bargain, but what you
see is what you get—unlike the glaciers, with their hidden crevasses and fragile
snow bridges.

South Mowich, Mowich,
and Puyallup Glaciers

A serac on Mount Rainier's Emmons Glacier

What Is It?

Mount Rainier and Glacier Peak

Bergschrund, crevasse, or serac?

If you want accurate definitions of these terms, turn to the book *Mountaineering: The Freedom of the Hills,* published by the Mountaineers Books. Mountain climbers know what bergschrunds, crevasses, and seracs are and that each can represent a major obstacle. But for a person with a camera, they represent a bonanza of photographic opportunities.

The photo at right is a simple depiction of a bergschrund, showing where the thicker and faster body of the glacier has moved away from the slower moving top portion, creating a fracture and a cliff of ice.

Crevasses, shown elsewhere in this book, are caused by the downhill movement of a glacier as it cracks open while going over humps and bumps in the rock bed beneath it.

At left is a serac caused by a crisscross of crevasses leaving pillars of ice that will eventfully crash, or might tip, as this one has.

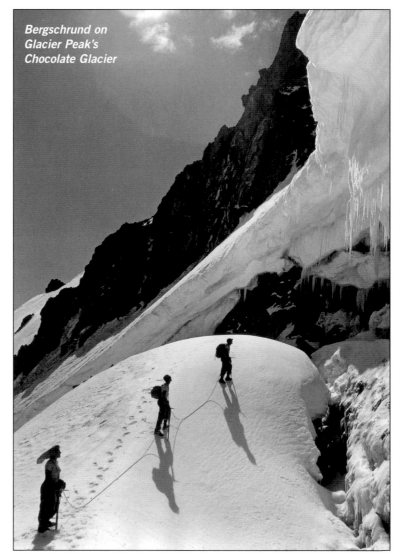

Bergschrund on Glacier Peak's Chocolate Glacier

*Sunrise on the side
of Glacier Peak*

Clouds

Glacier Peak Wilderness

"Above the clouds!" Those are words to stir the souls of citizens of the high world of the mountains. As sharply as though it were yesterday, I remember my first time hiking above the clouds—on a Boy Scout trek in the Olympic Mountains. I once spent a week above a cloud sea on Mount Rainier, while Seattle folks awoke every morning to a drizzle from heavy clouds just above their rooftops. At Camp Muir we had to put on sunglasses to get out of the tent.

This picture at left was taken at sunrise from Chocolate Glacier on the east side of Glacier Peak, on Pat's and my honeymoon. The first week we went backpacking in the Olympics, just the two of us. The second week I had to get back to work, so for a *Seattle Times* story, we joined the Mountaineers' summer outing on a circuit of Glacier Peak. Married a whole week, we frustrated a lot of sharp-eyed chaperones who had watched us before.

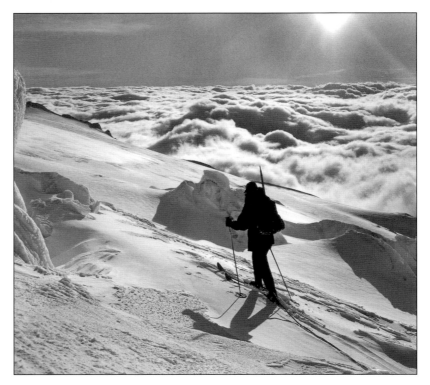

Above the clouds at Camp Muir

The morning we ascended the peak, our camp was in the fog from that good old onshore flow that makes Puget Sound such a green and pleasant land and Seattle the Emerald City. Before long, we emerged above a sea of clouds into bright sunshine.

Air view of
Mount Shuksan

Mount Shuksan

North Cascades National Park

When Dr. Otto Trott, who later became the Spring family physician, arrived in the Northwest in the 1930s from Germany, he quickly resumed the sort of mountaineering he was accustomed to, except that here it was more wilderness mountaineering than pure alpinism. But there was a good share of that to be found, too, and on his 1939 ascent of the Hanging Glacier route on Mount Shuksan he enjoyed a climb he considered fully up to the challenges he had faced in the Alps. Mountain history guru Fred Beckey calls it "the first technical alpine route" made on Shuksan. The Hanging Glacier is just around the corner of the ridge on the right. This aerial view at left shows some of the other good stuff on the north side of the peak—the Price Glacier flowing from the 9,131-foot Summit Pyramid and the 8,286-foot Nooksack Tower (first climbed by Beckey in 1946) on the left. On the right is Mount Baker, appearing appropriately modest in such company.

The Price Glacier ends at the shore of Price Lake, where we camped.

Airplanes might not give me a feeling of belonging, but they are a good way to see a lot of mountains. I love looking at places I have been and sketching routes in my mind of places I want to go. I discovered Price Lake from the air and found my way there a year later.

Roosevelt and Coleman Glaciers from Bastille Ridge

The Coleman Glacier . . . and a Treat

North Cascades National Park

On my several climbs of Mount Baker, I've always been impressed by the Coleman Glacier—very, very big; many, many crevasses. Usually, though, my ascents were in early summer, when these elements were mostly invisible under the winter's 10 feet or more of snow. A September trip was necessary for pictures. The low sun of fall gives dramatic highlighting to the ice, as well as backlighting. To get maximum effect, Pat and I slept at the trailhead, started out at daybreak, and reached Heliotrope Ridge just as the sun was coming up over the crest.

Mount Baker from Ptarmigan Ridge

September has other advantages, as the fords of meltwater torrents become simple boulder hops of friendly creeks. On the minus side, the wonderfully refreshing little waterfall that showers the trail in summer is almost dry.

Did I mention the blueberries? On our ascent, the sun was not yet over the skyline and the little blue jewels were frosty white and frozen hard—lucky for us, or we'd never have gotten to the glacier on time for the pictures. On the descent we spent so much time filling our faces and coloring our lips (and stomachs, no doubt) blue that we almost were benighted.

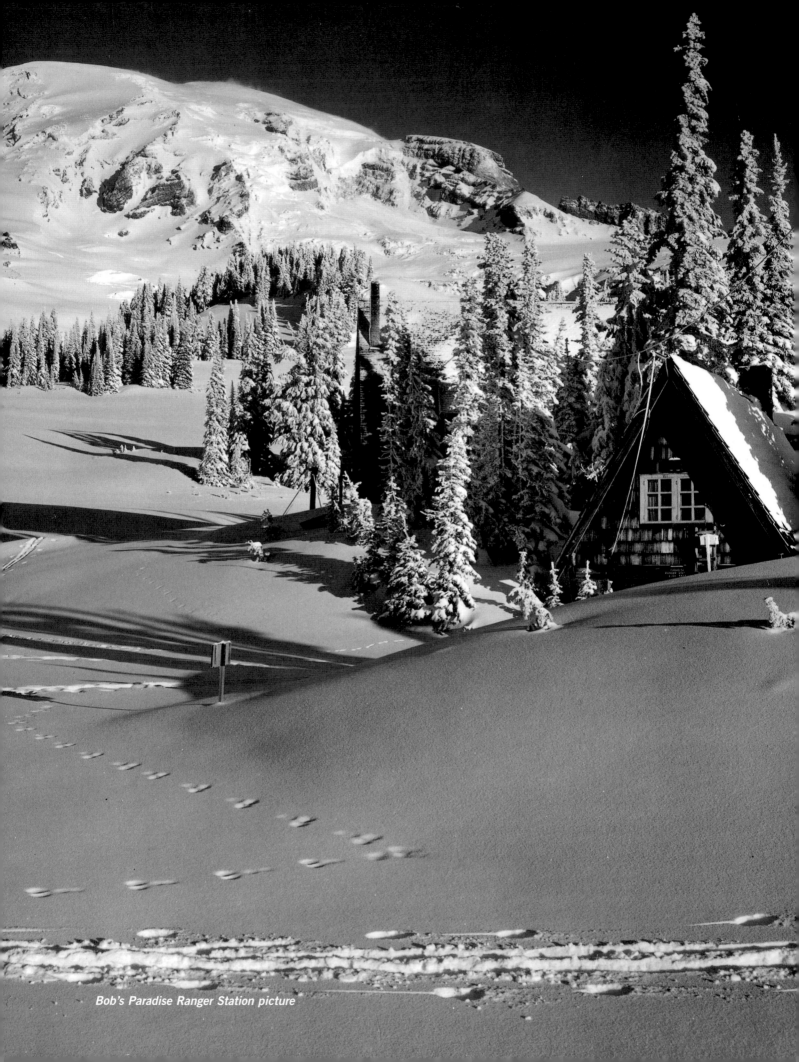

Bob's Paradise Ranger Station picture

Winter on the Mountain

Mount Rainier

Dee Molenaar, who guided at Mount Rainier while I photographed his customers back in 1940, went on to do the definitive book on the exploration and climbing history of The Mountain. He also went on expeditions to the Yukon, to K-2, and the South Pole (that one by airplane, not dogsled) and was the winter ranger at Paradise in 1948. The road wasn't plowed past Narada Falls, so he was snowbound for five months. The long winter gave him enough leisure time to develop the painting and mapmaking skills for which he is now famed. He invited us to spread our sleeping bags on the floor of the ranger station for a week.

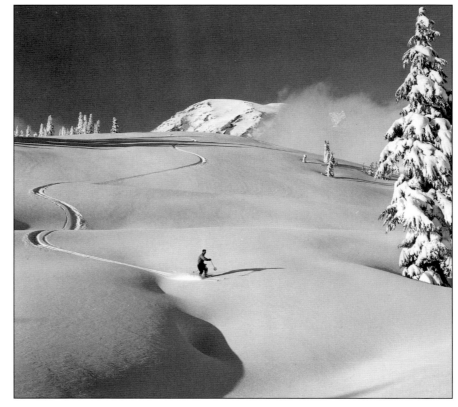

Powdered snow on Herman Saddle, Mount Baker

Dee recorded a snowfall of 28 feet that year—a new record, he thought. In summer he found that his snow pole had broken off 6 feet above the ground, so the depth was actually 34 feet, most assuredly a record.

Although Bob's picture was in black and white, it sold many times for calendars and books.

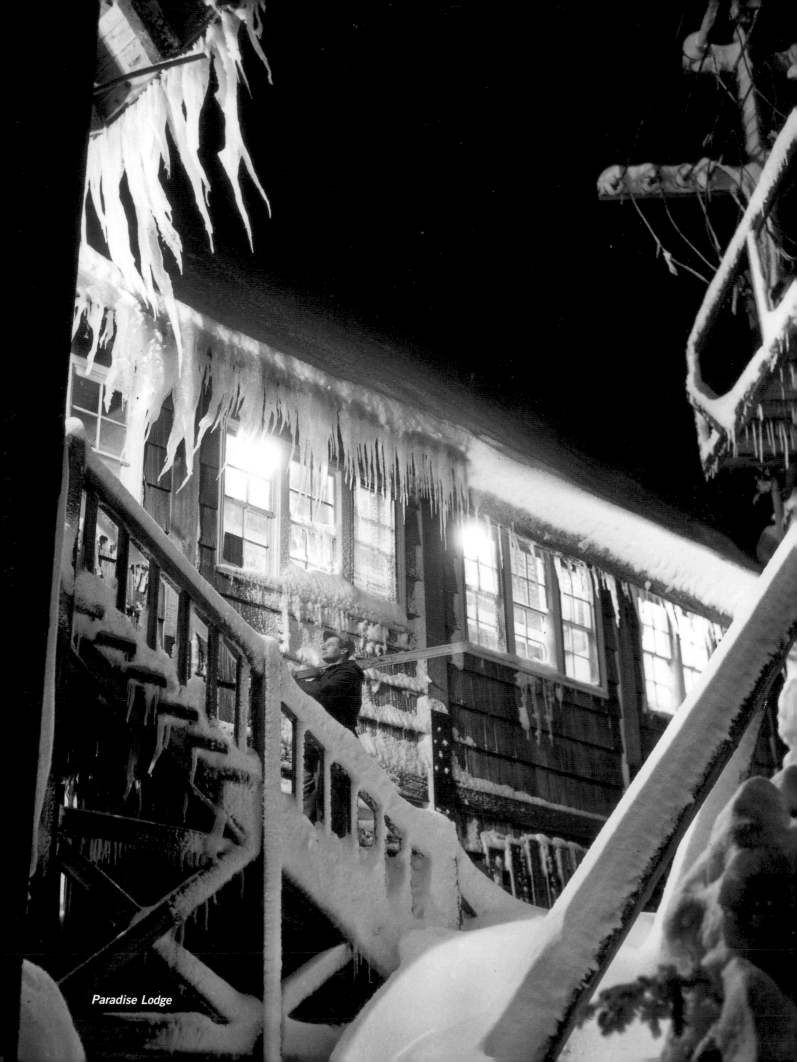

Paradise Lodge

Paradise Lodge

Mount Rainier

Paradise Inn dates from the 1920s. Paradise Lodge was built in the early 1930s and for many years was kept open for winter skiing. The inn is built on level ground, and downward pressure from the snow load is a danger. The lodge was on a bit of a slope, and the danger was from the sideways push. But when the parking lot adjoining the uphill side was plowed, there wasn't much of a problem. In the 1950s the road to Paradise was closed at Narada Falls, and the snow pushed the structure sideways until it was unsafe and had to be torn down.

Inner tube sliding

After the road was closed, and while the lodge remained open, we skied up from Narada Falls for stays of days or weeks. We would ski until dark, which comes very early in winter, and then would head for the lodge, whose cheerful lights in the night promised yummy hot meals and snug beds. It's not exactly wilderness, but it's not bad.

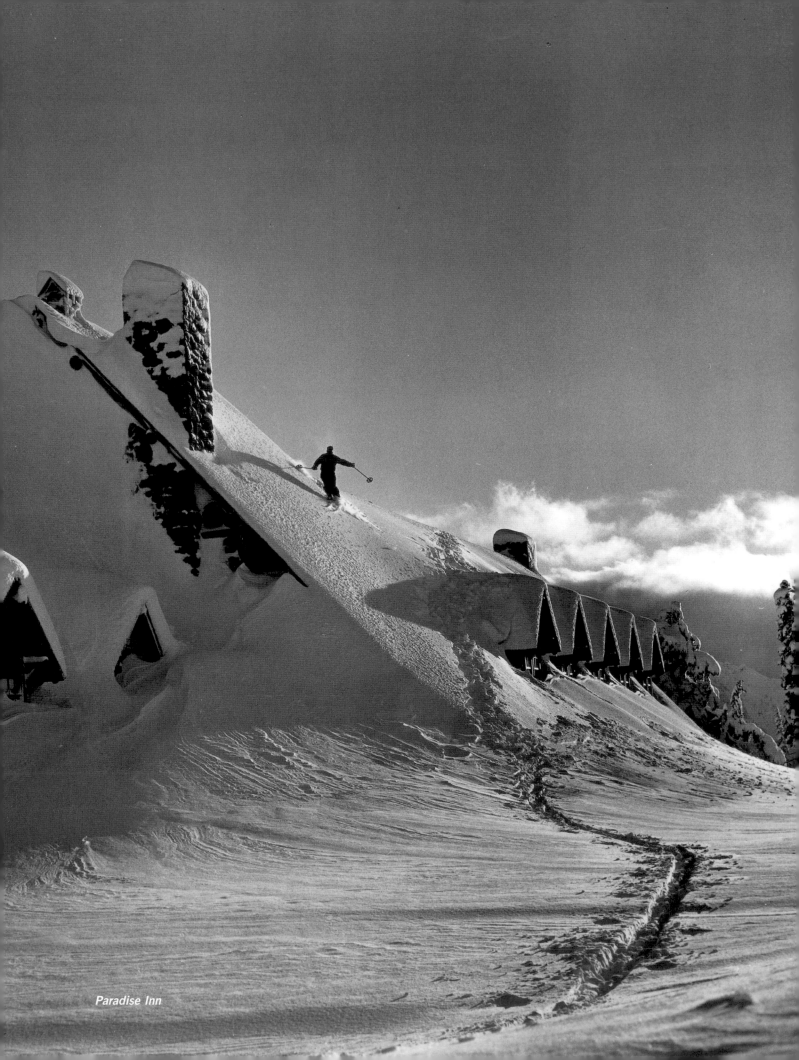

Paradise Inn

A Unique Ski Run
Mount Rainier

The day after the picture opposite was published on the cover of the *Seattle Times* pictorial section, a sign appeared: KEEP OFF. The Park Service knew that the following weekend every hotshot in Seattle would be stampeding to "ski the roof of Paradise Inn." The rangers have enough worries about the tremendous strain placed on the roof by a snowpack 15 to 20 feet deep. Each fall, special braces are installed.

In May a crew begins lightening the load with shovels and crosscut saws—misery whips, as loggers call them. Blocks of snow are cut, then slid off the roof—carefully! The bottom blocks obviously have to be removed first, and this removes support from the upper snow, which could avalanche on unwary workers below.

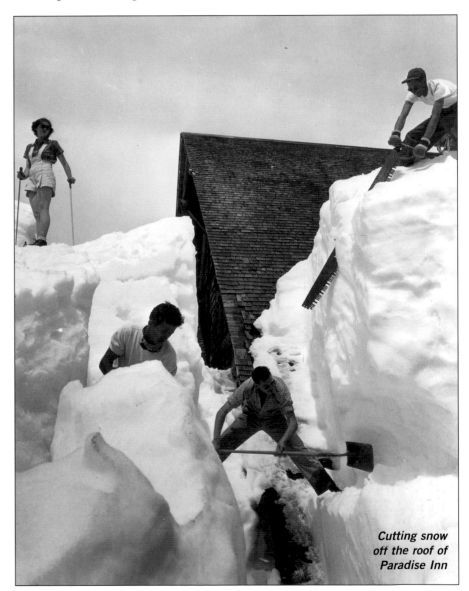

Cutting snow off the roof of Paradise Inn

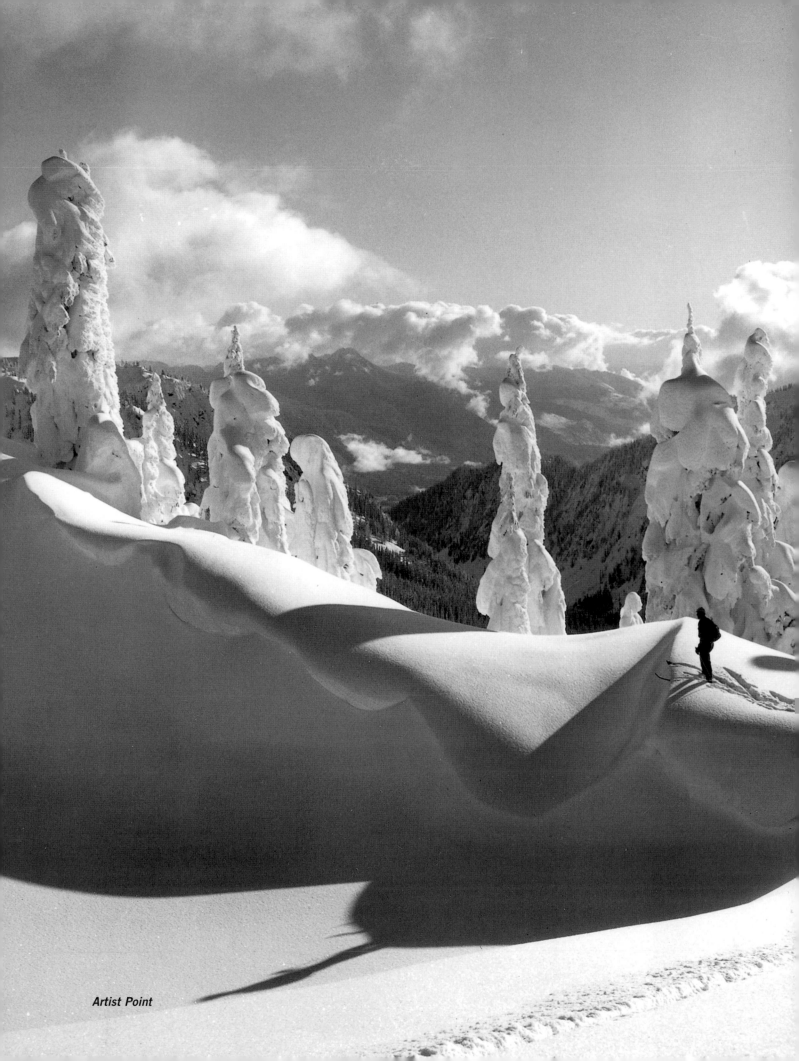

Artist Point

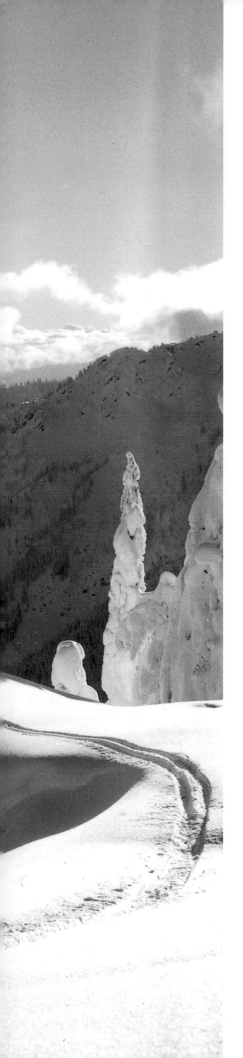

Artist Point

North Cascades

For my money, Artist Point after a snowstorm is the most photogenic place in the nation, if not the world. It is in precisely the right location for winds carrying sticky snow to plaster the trees. It also is one of the stormiest spots in the Northwest however, and the combination of plastered trees and bright sun is rare. There's no point waiting at home.

Even if you had a spy on the scene to report when the time was ripe, by the time you got there the trees would be melted bare, or the sun would be clouded over and the winds would be doing more plastering.

On the side of Table Mountain

Before Pat and I had kids to look after, we spent weekend after weekend at the Mountaineers' cabin in Heather Meadows. If lucky, we had one or two perfect days a winter. Most weekends it was just storm after storm. Even in bad weather it was beautiful, and we at least made our way to Artist Point. In better weather we climbed to Herman Saddle for the wide open slopes to ride down. But thank goodness for a hut with a hot stove and a tight roof to come back to. Time after time, when we set out to drive home, our station wagon was buried deep, with only the antenna sticking up to show us where to start digging.

Star tracks with Mount
Shuksan in the background

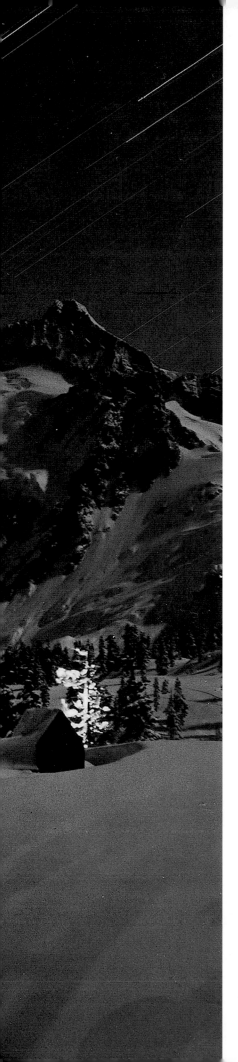

A Winter Dream

North Cascades

Before building their lodge at Heather Meadows, the Mountaineers leased the Gates Cabin. It had been built in the 1930s for the filming of Jack London's book *Call of the Wild*, starring Clark Gable.

Bob and Norma and their three kids and another couple with three children spent a week at the cabin. Bob came back with a bunch of great pictures. Best of them all was this time exposure from the cabin porch that he took of Mount Baker Lodge, Mount Shuksan, and those stars.

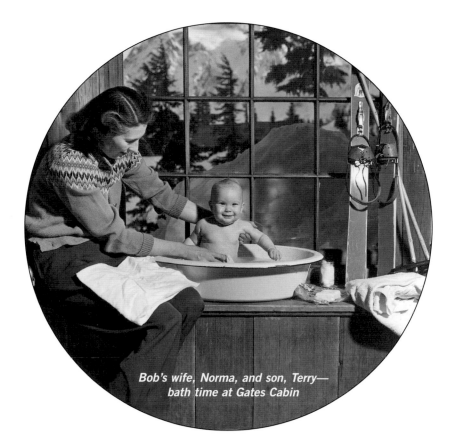

Bob's wife, Norma, and son, Terry—bath time at Gates Cabin

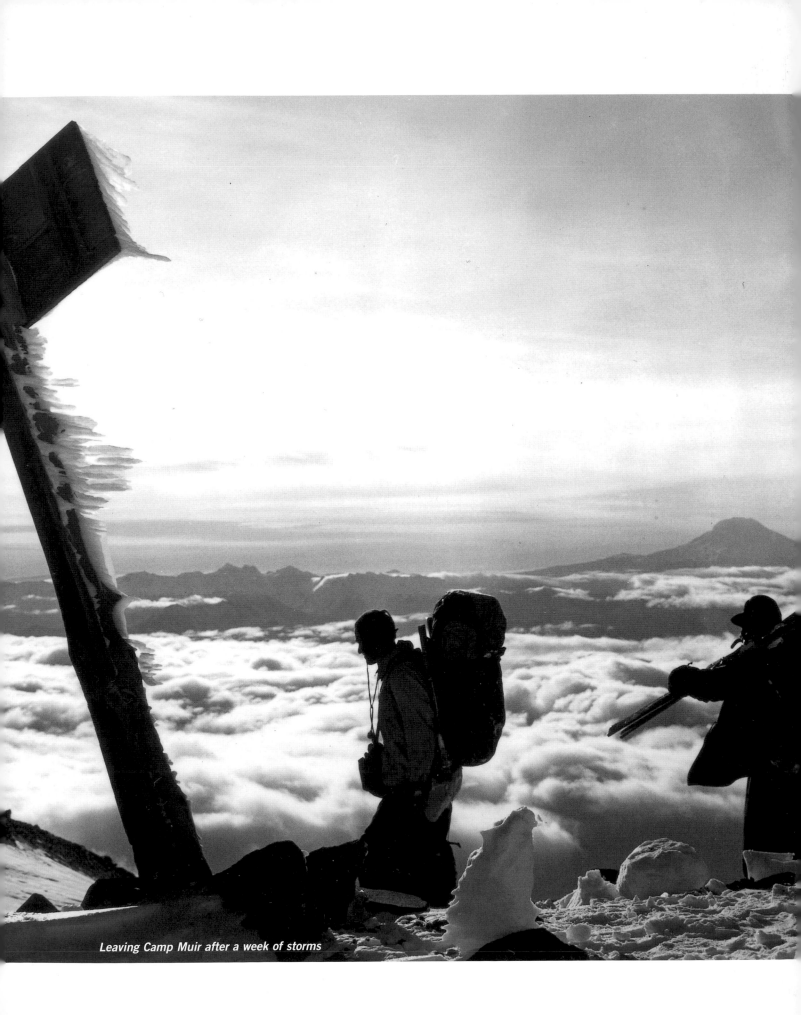

Leaving Camp Muir after a week of storms

Camp Muir
Mount Rainier

Bob and I and two companions spent a Christmas week at Camp Muir, having obtained official permission to stay in the guide hut, ever after known to us as the Icebox.

Our ascent was in decent weather, but that night a storm drifted a snowbank against the door, which was hinged outward. We were trapped. The push of four bodies managed to open the door just enough to reach out with fingers and a spoon to slowly begin shoveling. Once the door was open, we left it that way and hung a tarp in its place.

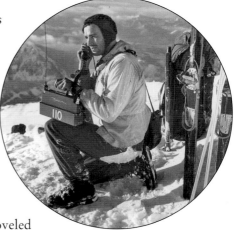

The storm blew four days. Later we learned from the U.S. Weather Service that winds were measured at 50 knots. They said that due to the funnel effect at Muir Saddle our winds doubtless were double that. The snowbank grew and grew, completely covering the side of the cabin. Having nothing better to do, we shoveled a subterranean network of tunnels—one around the corner

Ira using the park's radio

to the lee of the cabin to let us in and out, another to a room that served as our outhouse.

On our last day the sun came forth. Since we knew the ski down would take only an hour, we went out to photograph the Nisqually Glacier. In late afternoon we ate our last bit of food, lifted our eighty-pound packs, strapped on skis, and headed for home. In less than a mile, the snow surface gave way to ice. For a week snow had fallen at 10,000-foot Camp Muir, but below 9,000 feet rain had fallen for the week—and on the first cold day the snow had frozen solid. Taking off skis, we roped up and began the slow process of chopping steps and belaying. Night caught us at Panorama Point. To proceed in the dark was risky, so we bivouacked. Our gear kept us warm enough to stay alive, but there was some fear we might starve to death. In the morning however, we had a good hot breakfast at Paradise.

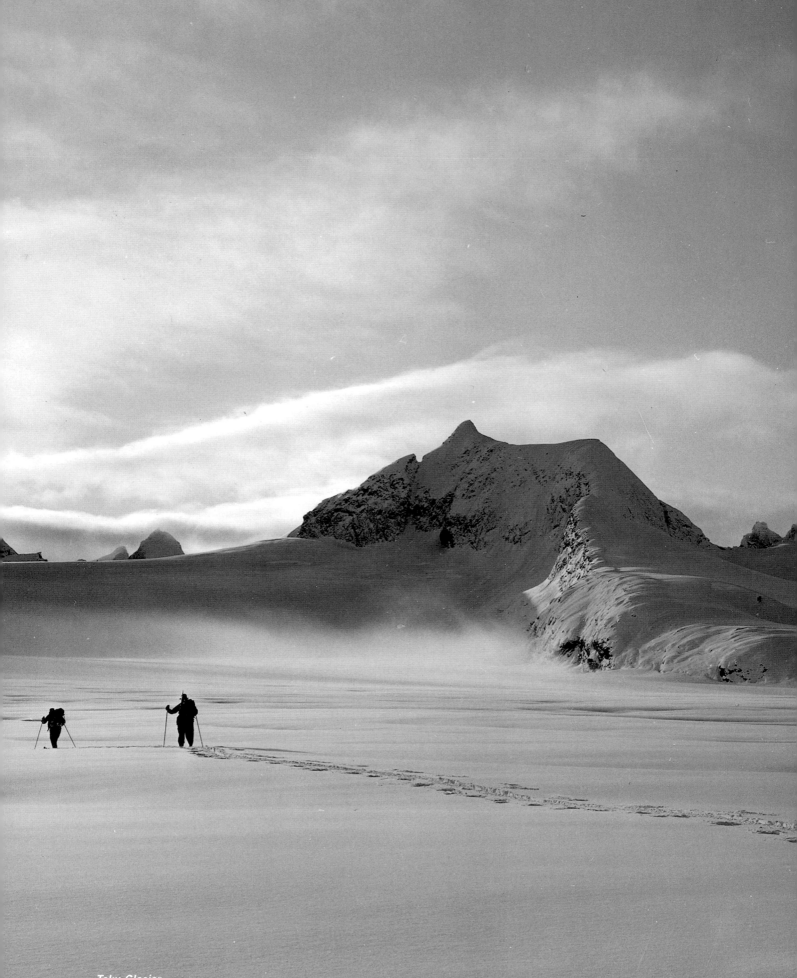

Taku Glacier,
Juneau Ice Field

A Frozen Adventure

Alaska

In November 1953 my friend from Mount Rainier, Maynard Miller, director of a research program on the Juneau Icecap, invited me to join him for ten days on the Taku Glacier.

We were flown from Juneau to the Alaska-Canada border in an Army amphibian plane equipped for landing in snow. That it did, smoothly. The taking off was the hard part. The snow was too wet and sticky to attain flying speed. Repeated attempts used so much fuel that the Army had to air-drop more. Then a storm dumped 10 feet of snow on us. More air-drops and lots of shoveling, and it took ten more days before we got to work on Maynard's project.

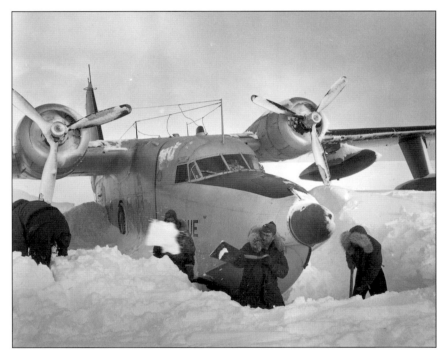

Army airplane almost buried on the Taku Glacier

When we were done, we hoisted ninety-pound packs for the 30-odd-mile hike to Juneau. The sky was clear, the temperature well below zero, the wind fierce, and the snow soft. Add three days, bringing the total time from the anticipated ten days to the actual five weeks.

The photos I shot on the way to Juneau were so dramatic that I hurried to my darkroom at home in high excitement. Well, it had been plenty cold and I hadn't broken up. The film however, had become brittle and did break. I lost every one of those dramatic pictures.

*Quien Sabe Glacier
in Boston Basin*

Sahale Arm

North Cascades

May is the choice month for ski mountaineering. The days are longer, and the high country is still under snow but valley roads aren't. Boston Basin and Sahale Arm are my favorites. The Cascade Pass Trail offers easy access in summer but in winter and spring is an avalanche trap. We found safe passage in the forest via Boston Basin, where we camped in the snow for ventures higher. Once we camped on bare, flat ground atop the arm itself. Evidently this was home to ptarmigans, which kept us awake all night with their chattering. When it was light enough for me to get out my camera, they vanished, of course. In 1950 the little Quien Sabe Glacier (who knows where that name came from) displayed a lot of ice and some very big crevasses. The last time I was in Boston Basin, the glacier was hardly there at all, reduced to a late-summer snow patch, a vanishing memory of the Little Ice Age that began in the fourteenth century and pretty well petered out in the early twentieth.

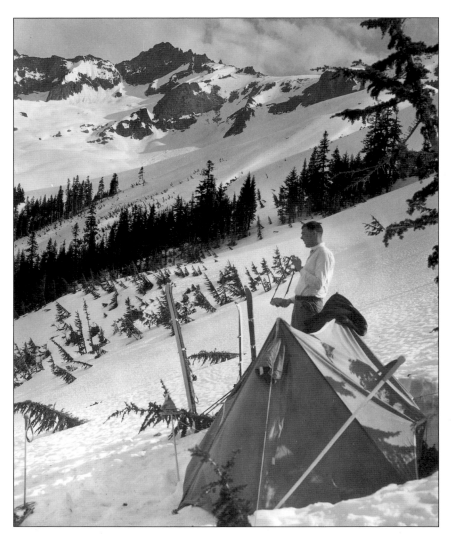

Camping in Boston Basin

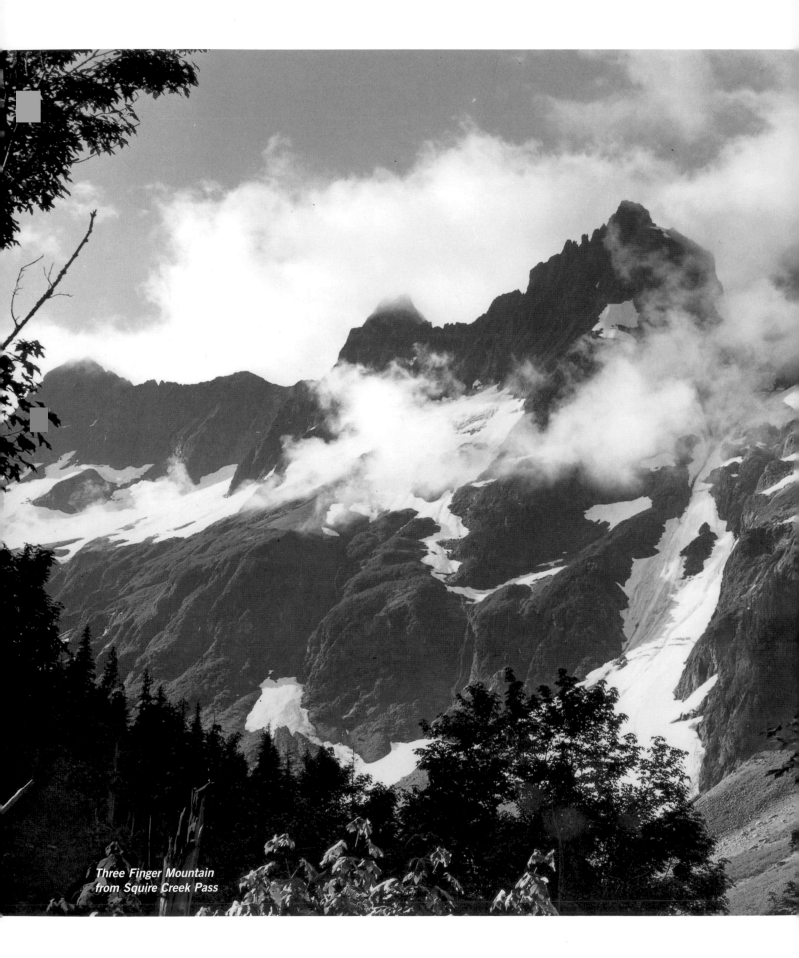

Three Finger Mountain
from Squire Creek Pass

Book Work

Boulder River Wilderness

When the *100 Hikes* series expanded to devote an entire volume to the Glacier Peak area, I put in a full summer, and a good part of the fall as well, filling gaps in my knowledge. I postholed through several feet of new snow to reach Squire Creek Pass. Then I had to squirm around in the trees for clear shots of Three Fingers and the tall wall of Whitehorse. The sun was out, but the air was darn cold. When you watch the waterfall of a swift little creek becoming icicles before your eyes, that's *cold*.

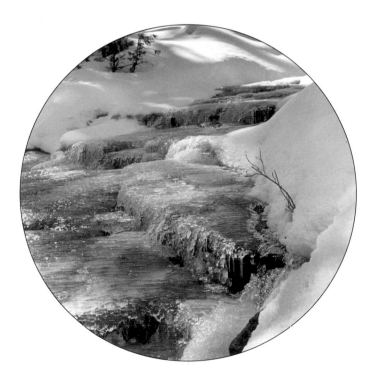

Frozen stream
at Squire Creek Pass

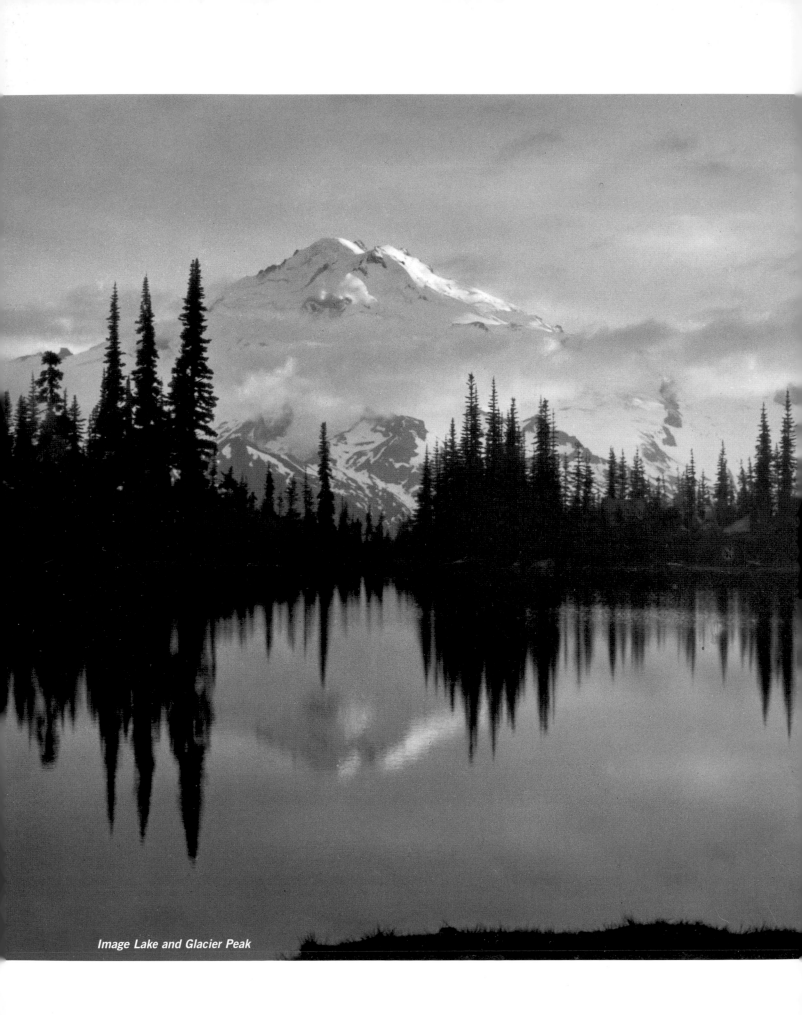

Image Lake and Glacier Peak

Scenic Shots

Glacier Peak Wilderness

One still occasionally hears from lazy folks who want to see the world from a car window and who spout the old blather that "the aristocracy of the physically fit" seek to "lock up the best scenery" so that ordinary folks can't get a look. Well, take it from the experts—the art directors in New York City who buy pictures for scenic calendars—most of the great and famous shots are taken a few feet from a road.

Since 1947 Bob and I have sold hundreds of calendar photos, and in the process we have offered thousands of photographs for the directors to choose among. They don't give a darn whether a picture was taken from a car window or 30 miles in on a trail. It just has to be beautiful. Almost invariably their choices are those that were easiest to reach. Mount Rainier from Paradise Valley, Mount Baker from Artist Point, Mount Shuksan from Heather Meadows, the Grand Tetons from the highway through Jackson Hole—every outdoor photographer trying to make a living has these images in his portfolio. At the Grand Canyon I hiked down to the river, a grueling round-trip on a summer day; the picture I sold was taken from the parking lot on the rim.

The three exceptions to the rule in my portfolio are the Enchantments and White Rock Lakes, which were still covered with glaciers during the road-building spree of the 1920s and 1930s, when America fell in love with the motor car. The third exception was Image Lake. Fortunately, in the age of America's craze for "the freedom of the wheel," the civil engineers didn't know about these places. If they had, there sure as shooting would have been roads. The West Side Highway in Mount Rainier National Park was planned to be the beginning of a Wonderland Highway around the mountain. Cross-mountain roads were surveyed in the Olympics from Staircase to Lake Quinault, up the Dosewallips and over Anderson Pass to the ocean, and from Hurricane Ridge to Deer Park. A band of wild-eyed environmentalists and President Franklin Roosevelt put a stop to the butchery however, and now we have wilderness trails there instead.

Lewis River Trail

What It's All About

Green-bonding

"Green-bonding" is akin to a child's bonding to its parents. It's what a person feels when he or she walks through a forest of ancient trees or a field of wildflowers, takes a dip in a tarn or a drink from a waterfall, is riveted by a dramatic view, sweats for miles on a trail, or climbs a mountain. Green-bonded people are the defenders of wildness, as important to them as the air they breathe.

Rangers' Walk at Mount Rainier

Defenders are urgently needed. There have been attempts in Congress to sell the timber and minerals of "surplus" national parks and wilderness areas. The 1964 Wilderness Act is under attack by the Wilderness Act Reform Coalition of industry and its spokespersons in government. Loggers and miners seek to broaden their base of citizen support, advocating motors and bicycles on wilderness trails.

To date, we defenders have been able to protect our own, but the population is shifting. We are in danger of becoming a minority, easily marginalized to insignificance by a Congress with other priorities. Will there be enough of our green-bonded people in decades ahead?

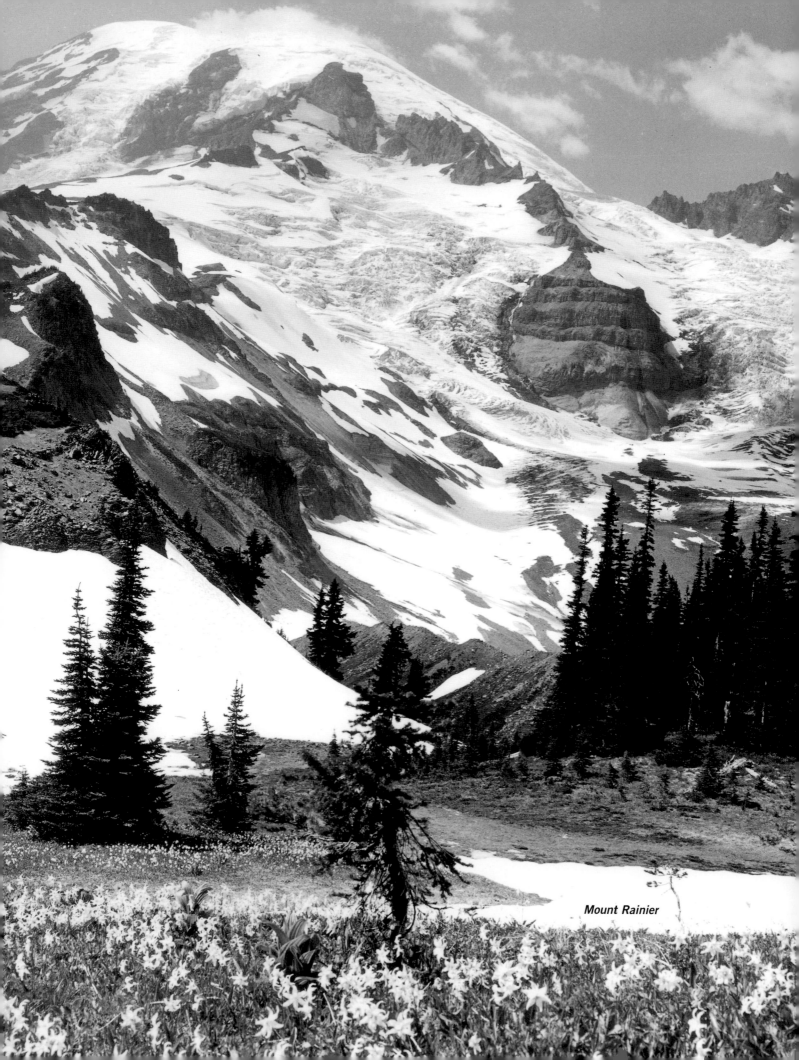

Mount Rainier

The Spring Family Trust for Trails

Throughout his life, Ira Spring was passionate about preserving the scenery he loved to photograph. Unlike many of his contemporaries, who wanted to save the wilderness and mountains by limiting access to most scenic locations, Ira felt that the only way to preserve our mountains and wildlands was to encourage more people to visit, explore, and ultimately become as ardent about their preservation as he was.

In the early 1990s, Ira became a founding member of the Washington Trails Association. This group is dedicated to preserving access to the wilderness by maintaining trails and its volunteer trail crews are now major contributors to the trail building and maintenance efforts in the state of Washington.

Ira realized that the volunteer effort would not be enough. The government funding for trail building and maintenance was continuing to dwindle. Bridges and turnpikes were falling apart because the funds required to purchase the materials were no longer available.

In 1999, Ira formed the *Spring Family Trust for Trails*. This charitable foundation is dedicated to enhancing hiking opportunities with grants for trail building and maintenance projects. All his income—including all royalties received from this book—go to the trust. The trust also accepts private contributions from like-minded wilderness supporters.

One of Ira's favorite sayings was, "What Congress giveth, Congress may also taketh away." Referring to the massive swell of public support that induced Congress to pass the Wilderness Act in the 1964, he believed that if the public were to lose interest in maintaining our wilderness areas, Congress could someday pass a ruling that would remove some or all of the protection that keeps developers out of our wildlands.

To guarantee that our wilderness areas remain in place for future generations, Ira felt that it was vital to foster a love of the outdoors in young people. He was a strong supporter of outdoor education for children and encouraged families to get involved in hiking and trail maintenance projects.

To learn more about the Spring Family Trust for Trails visit the Web site at www.springtrailtrust.org.

Ira and Bob Spring
on Mount St. Helens